WORLD WAR II HAWAII

IMAGES of America

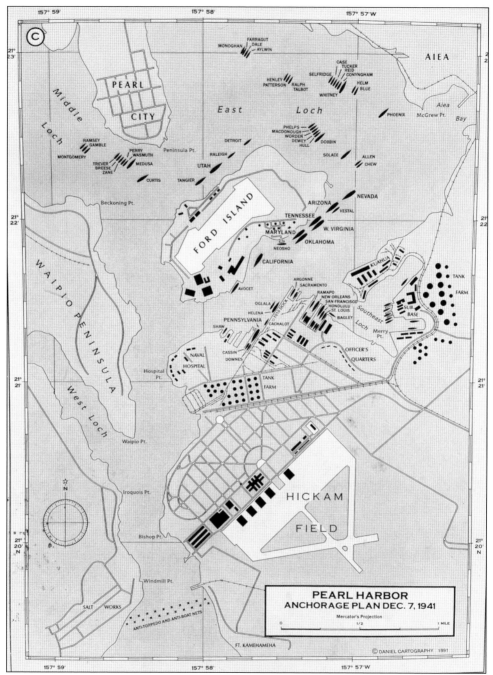

This map of Pearl Harbor shows the position of all the ships in port at 7:55 a.m. on Sunday, December 7, 1941. It also helps to illustrate how close some of the neighborhoods were to the destruction at the base, such as Pearl City and Aiea. (Courtesy of Hawaii War Records Depository.)

ON THE COVER: Army maneuvers were a common sight in downtown Honolulu. Here, light tanks assemble on the McKinley High School campus to practice an attack on opposing enemy forces. Before the practice, a tanker chats with children. (Courtesy of Hawaii War Records Depository.)

IMAGES
of America

WORLD WAR II HAWAII

Dorothea N. Buckingham
and John C. Buckingham

Copyright © 2024 by Dorothea N. Buckingham and John C. Buckingham
ISBN 978-1-4671-6177-0

Published by Arcadia Publishing
Charleston, South Carolina

Printed in the United States of America

Library of Congress Control Number: 2024932324

For all general information, please contact Arcadia Publishing:
Telephone 843-853-2070
Fax 843-853-0044
E-mail sales@arcadiapublishing.com

Visit us on the Internet at www.arcadiapublishing.com

For Charlie

Contents

Acknowledgments		6
Introduction		7
1.	Bombs Fall	9
2.	Winds of War	27
3.	Martial Law	33
4.	War Zone	45
5.	Daily Life	61
6.	Off Duty	89
7.	Americans of Japanese Ancestry	105
8.	A New Era	111
9.	Places to Visit	125

Acknowledgments

This book reflects decades of research into life in Hawaii during World War II and the assistance of tens of people who guided us. To name them would be an impossible task. However, we gratefully thank the survivors of the attack on Pearl Harbor and the men and women who lived in Hawaii during that time who shared their stories. To all the staff and faculty of research institutions, libraries, and universities who addressed our requests and directed our research, thank you. To all members of the institutions listed below, *mahalo*. Unless otherwise noted, the photographs in this book are from the Hawaii War Records Depository at the University of Hawaii. This collection of over 2,400 photographs includes images of the US Army; the US Navy; the *Hawaii Advertiser*; the *Hawaii Star-Bulletin*; the Pan Pacific Press; the American Red Cross; the United Service Organizations (USO); archived collections of churches, schools, and social organizations; and personal collections. Special thanks to Jay Sturdevant at the USS *Arizona* Archives at the Pearl Harbor National Memorial. We could not have done this without archivist Sherman Seki. Thanks, Sherman.

Photographs not from the Hawaii War Records Depository are credited with the initials below. This list also includes institutions that have contributed to the research in this work.

(Please forgive any errors found; they were unintentional. The omission of Hawaiian diacritical marks was intentional and reflects the spelling during the war years. The word "alien" was used to denote a noncitizen resident of Hawaii during that time.)

Hawaii State Archives, Historical Branch	HSA
Hawaii State Historic Preservation Division	SHPD
Hawaii Historical Society	HHS
Hawaii State Public Library System	HSL
Hawaii War Records Depository	HWRD
Hawaii's Plantation Village	HPV
Hawaii Sugar Planters' Association	HSPA
Japanese Cultural Center of Hawaii	JCCH
MacKinnon Simpson	MKS
National Archives	NA
Navy Historical and Heritage Command	NHHC
National Park Service, USS *Arizona* archives	NPSA
National World War II Museum	WWM
North Hawaii Education and Research Center	NHERC
Pearl Harbor Aviation Museum	PHAM
Sisters of the Sacred Hearts, Province Hawaii	SSDH
Ted Chernin	TC
US Army Museum of Hawaii, Fort DeRussy	USAMD
University of Hawaii, Center of Oral History	UHCOH
University of Hawaii, Hawaiian & Pacific Collection	UHHP
University of Hawaii, Map Collection	UHMC

Introduction

World War II cast its shadow of devastation across the entire world, its horror was immediate and violent. Alongside the staggering toll of 15 million military personnel, estimates suggest civilian deaths soared upwards of 50 million, leaving an indelible mark on the character and standards of our world well into the 21st century. While the vast oceans served as a buffer, insulating the Americas from the direct onslaught of the Axis powers, one territory stood starkly exposed: Hawaii.

December 7, 1941, forever etched in memory as a day of infamy, thrust the United States into the maelstrom of a global conflict. The US Pacific Fleet, having strategically relocated its headquarters to Pearl Harbor in 1940 to assert its military might in anticipation of a looming confrontation with the Empire of Japan, found itself squarely in the crosshairs of the Imperial Japanese Navy. Though military strategists foresaw small triggering events leading the United States into war, the magnitude of the raid on Pearl Harbor surpassed all expectations, delivering an unexpected shock to the citizens of Hawaii.

Yet, despite the surprise, Hawaii was not wholly unprepared for the storm of war. The military had initiated a substantial expansion and buildup of facilities and bases on Oahu, anticipating the inevitable struggle. In 1940, Congress appropriated tens of millions of dollars to fortify the Hawaiian islands for war, flooding the territory with additional supplies, equipment, and troops. Army troop strength swelled to 25,000, while Navy personnel numbered over 5,000 officers and men, in addition to the crews of over 100 ships of all sizes stationed in Pearl Harbor. The US government poured $210 million into military expenditures in 1941 alone, not including the additional funds appropriated for military construction, quadrupling the previous year's total.

As early as 1939, recognizing the potential for food shortages in the event of war, an emergency feeding committee was organized by the home economics division of the Department of Public Instruction. By early 1941, this committee had recruited 1,000 volunteer workers and submitted plans to feed the public at school cafeterias. The Major Disaster Council commenced planning, developing contingencies for the safe evacuation of patients in hospitals vulnerable to attack or damage in air strikes to selected schools, and training over 4,600 first aid unit volunteers to staff these facilities by September of that year.

To meet the escalating demand for infrastructure, construction projects proliferated throughout the territory. Local workers abandoned low-paying jobs in agriculture in droves, but despite that personnel migration, the workforce remained insufficient. In the first four months of 1941 alone, the Hawaii Sugar Planters' Association reported a loss of over 800 workers. Furthermore, in anticipation of war in the Pacific, the military appropriated much of the plantation lands for camps and training, even appropriating the sugar companies' rail systems to mobilize equipment and supplies.

Mainland construction companies recruited workers under contract to meet the demands of the building industry in Hawaii. Persistent concerns regarding food and housing were exacerbated as Oahu's population swelled, straining the island's resources. Despite efforts by the Hawaii Sugar Planters' Association to assess its acreage for emergency crop production, it was determined that stockpiling a reserve food supply was the only viable solution, given that 80 percent of Hawaii's food was already imported from the mainland by ship.

The sheer devastation of the December 7 attack overwhelmed even the most meticulous preparations. In less than two hours, the raid by the Imperial Japanese Navy left 68 civilians and over 2,300 military personnel dead. The urgency of the situation quickly outpaced the preparations of both the territorial and US governments.

Within hours, martial law was declared in Hawaii, a drastic measure approved by President Roosevelt that remains unparalleled in US history as it was the only time that a military government was instituted to replace the civil one. Habeas corpus was suspended, and thousands of local Japanese were investigated for potential threats, resulting in approximately 2,000 internments. However, the vast majority of the approximately 150,000 residents of Japanese descent in Hawaii were spared internment, as they represented 38 percent of the total population and played vital roles in the economy and community.

In the weeks following the attack, 20,000 military dependents in the islands were marked for evacuation, with only essential workers permitted to remain. Their vacated military base housing was repurposed for civilian government employees and contractors, doing little to meet the demand brought on by the influx of civilians. Owing to the concerns over possible invasion or at least potential sabotage, essential services and infrastructure came under round-the-clock armed guard. The iconic Iolani Palace, the historic residence of Hawaii's kings and queens during the monarchy period, fell under the jurisdiction of the Office of Military Government and was surrounded by newly erected buildings and fortified with bomb shelters and trenches.

While gasoline rationing was implemented nationwide, Hawaii faced more severe restrictions due to heightened competition for fuel from military operations. The average automobile owner was allowed about 11 or 12 gallons a month, and the single refinery in the islands was barely able to keep pace with that. A 1941 Ford got about 17 miles to the gallon for reference. Japanese submarines attacked fuel storage and infrastructure at harbors in Kauai, Maui, and Hawaii Island. In January 1942, the transport ship *Royal T. Frank* was sunk off Hana, Maui, killing 29. A long-range Japanese seaplane, lost trying to bomb Pearl Harbor, dropped its bombs less than 300 yards from Roosevelt High School in March 1942.

Despite military reassurances that Japan had no plans to invade Hawaii, continued aggression was expected as they consolidated their positions in southeast Asia and the western Pacific. To bolster defenses, the Organized Defense Volunteers, a first-of-its-kind organization, was formed, eventually numbering over 20,000 volunteers in different roles and units. The commitment and dedication of units such as the Hawaii Rifles, Hawaii Air Depot Volunteers, Businessmen's Military Training Corps, and the Women's Army Volunteer Corps bolstered confidence in Hawaii's defense capabilities and provided much-needed relief to the Hawaii Army National Guard and garrison Army troops who could then be committed to train and deploy in the Pacific campaign while the volunteers committed to the protection of their home.

The war changed Hawaii forever. Literally millions of men and women were exposed to the "paradise" of the islands and the warmth of its people, and many of them returned repeatedly over the years following. Numerous men married local women and chose to remain and make Hawaii home. The impact of the exposure of local men and women to the trappings of mainland life, including wages and leisure, led to an expansion of labor unions, and the politics of the territory changed dramatically until, in 1954, the Democrat party became the majority. Returning 442nd troops went on to become leaders, and it was their role during the war that played a significant part in Congress voting statehood for Hawaii.

Hopefully, this book will help uncover the role Hawaii and its people played in the war in the Pacific and their dedication and hard work that led to Hawaii's place today.

One

BOMBS FALL

On the morning of December 7, 1941, Hawaii's usual calm was abruptly shattered as the tranquility over Oahu disintegrated into chaos when the Imperial Japanese Navy launched a surprise attack on Pearl Harbor, the home of the US Pacific Fleet as well as other military installations around Oahu.

Through a collection of black-and-white photographs, many captured in the immediate aftermath of the assault, this chapter delves into the impact of the attack on the people and infrastructure of Hawaii. They freeze moments of destruction, showcasing the stark contrast between the once-peaceful island and the wreckage left in its wake as well as rarely seen images of the damage to businesses and homes and injuries to the civilian population of Honolulu.

The response of the islanders as they grappled with the sudden assault on their homeland was heroic and unselfish. While war with Japan had been considered by military strategists, none had considered the level of violence this surprise attack meted out. The shock and sense of betrayal were even greater for the citizenry as they feared invasion at any moment.

Beyond the initial impact, the beginnings of the transformation of Hawaii into a strategic military outpost and staging area for war are explored. The response to the attack, including mustering and arming civilian volunteers, military appropriation of private buildings and lands, and even the declaration of martial law, altered the islands, leaving a lasting imprint on their identity.

Hawaii became a pivotal player in the Pacific theater, and the dual nature of the islands during this period became clear, simultaneously serving as both a paradise for servicemen resting and rehabilitating between missions and a strategic military stronghold.

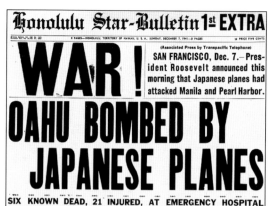

On December 7, the *Honolulu Star-Bulletin's* headline screamed, "WAR! Oahu Bombed by Japanese." But the *Honolulu Advertiser* never put out a newspaper. On December 6, its presses jammed. The pressmen tried different solutions, eventually arranging with the Japanese-language newspaper *Nipon Ju Ju* to print for them. But by that time, the war had begun, and the *Advertiser* never printed a war edition.

The USS *Arizona* (BB-39) had a crew of 1,511 officers and men and a Marine Detachment of 88 officers and men. Her sinking on December 7, 1941, killed 1,104 sailors of the 1,300 aboard and 73 Marines of the 88 aboard. Over 850 of the sailors and 52 of the Marines remain entombed aboard, considered buried at sea. While no longer a commissioned vessel, *Arizona* is considered a military cemetery.

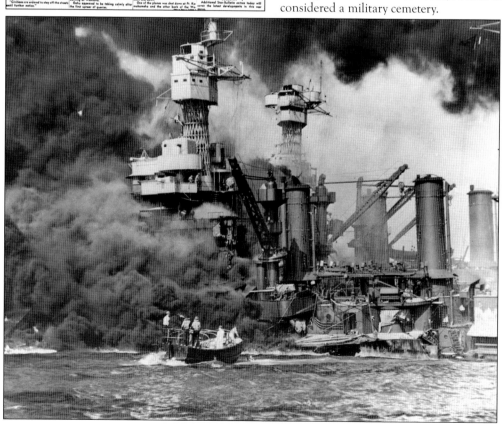

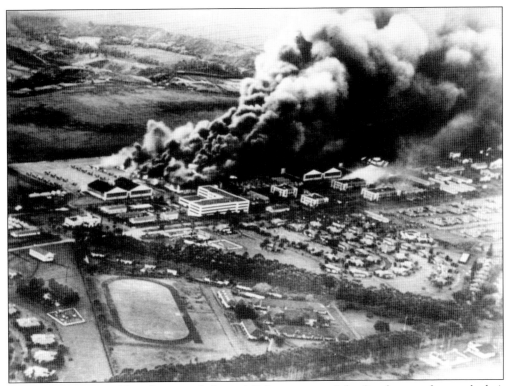

Wheeler Army Airfield in the central plain of Oahu was one of the first bases to be attacked. A total of 33 soldiers were killed and 73 were wounded. A total of 76 aircraft were destroyed and 60 were damaged. The smoke from the hangar fire shown here hid most of the P-36s, and few of them were damaged.

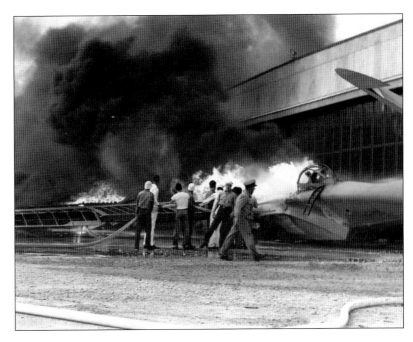

The attack of December 7 struck all the major bases on Oahu. The sailors here struggle to save a PBY Catalina at Naval Air Station Kaneohe. Of the 36 Catalinas assigned to Patrol Wing One, all were destroyed except the three on patrol during the raid.

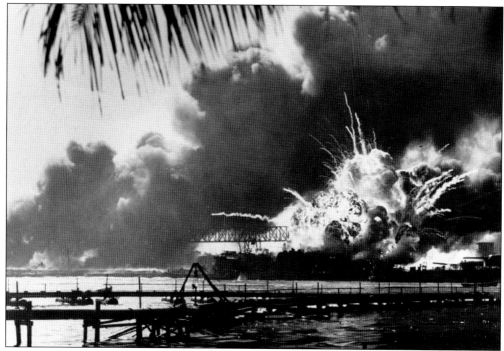

The destroyer USS *Shaw* (DD-373) was in Floating Dock YFD 2 during the attack. She was struck with three bombs, and the hit on her No. 1 magazine blew the bow off the ship. A total of 23 crewmen were killed. After a survey of damage, it was determined the ship's engineering spaces were serviceable. A temporary bow was welded on her, and she sailed back to California for repairs. She returned to service throughout the Pacific campaign.

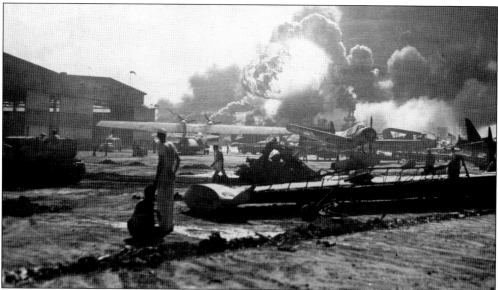

This iconic photograph shows the damage to PBY Catalinas at Naval Air Station Ford Island. The only target on Ford Island, hangar No. 6, the home of Patrol Wing 2, was significantly damaged, along with six of the wing's Catalinas. Five more were damaged, and the remainder were out of commission for days.

All of the major military installations on Oahu were damaged in the attack. The flag in this photograph became an iconic symbol and was located in the center of the base at Hickam Field, on the circle fronting the headquarters. The main barracks and mess hall are visible in the rear. Seventy-six aircraft were destroyed, 189 soldiers were killed, and another 303 were wounded.

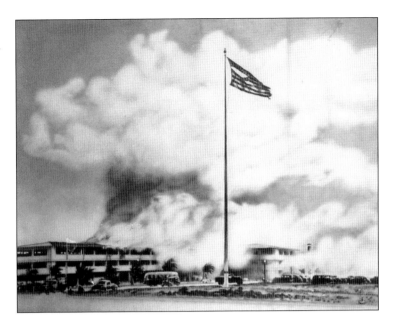

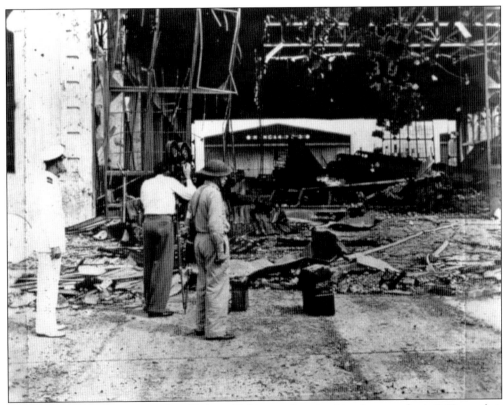

Severe damage to hangar No. 1 at Hickam Field is evident in this photograph. A B-18 wreck is visible in the right rear of the hangar as the survey team films the damage.

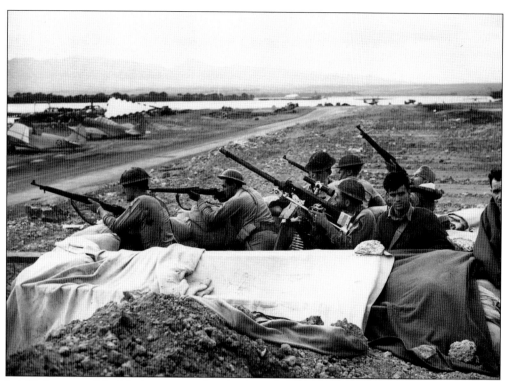

It is likely many of the Marines assigned to the three defense battalions not on duty were asleep or at breakfast on their only day off when the attack occurred. These Marines man a position likely on Ford Island, with whatever weapons they were able to collect.

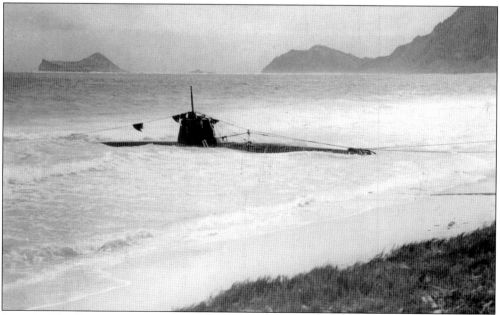

A total of five Japanese two-man subs were discovered, including the one sunk at the mouth of Pearl Harbor. This one beached at Bellows Field, where its surviving crewman surrendered to the Hawaii Army National Guard, becoming the United States' first prisoner of war.

The USS *Enterprise* (CV-6) and her air group were out of port on December 7. Returning that evening to Naval Air Station Ford Island, five of this type of F4F Wildcat aircraft were shot down by friendly fire, killing three pilots and wounding two.

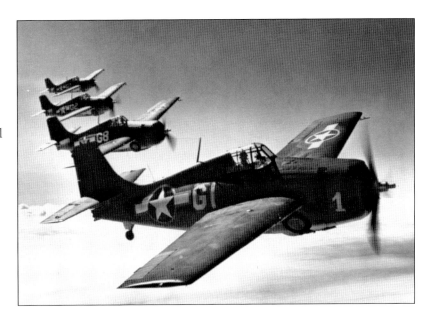

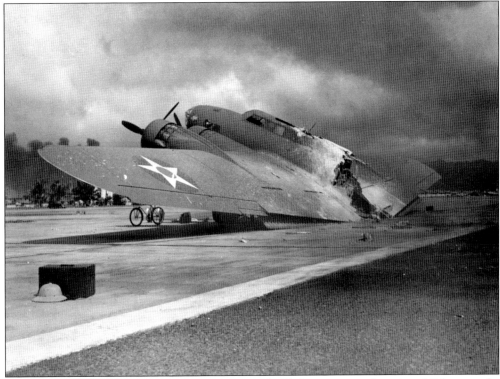

A flight of 12 unarmed B-17 bombers, en route to the Philippines, was flying into Hickam on the morning of December 7, 1941. They arrived in the middle of the attack and had to disperse to avoid the Japanese fighters. Incredibly, all 12 were able to land without being shot down, but one was forced to land on the seventh fairway at Kahuku Golf Course and another landed at Bellows Field. This one was destroyed on the ground at Hickam after landing. Miraculously, there was only one death among the crew, flight surgeon William Shick.

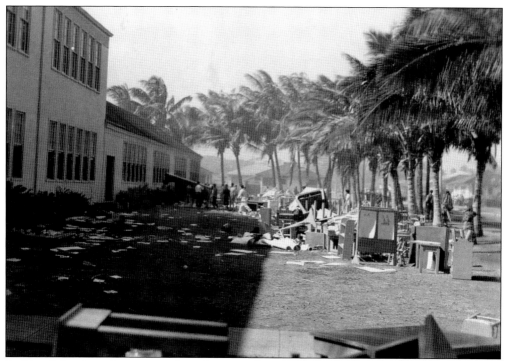

In Honolulu, three fires occurred in the McCully neighborhood. One was at Lunalilo School, which was being used as an evacuation center. When the fire erupted, Red Cross volunteers, including McKinley High School senior "Danny" Inouye (later known as Sen. Daniel K. Inouye), rescued evacuees by carrying them from the buildings to safety on the lawn.

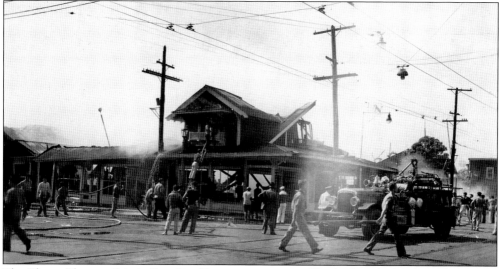

The Cherry Blossom Saimin Stand in Chinatown was owned by the Hiraski family. Eight-year-old Jackie, three-year-old Robert, two-year-old Shirley, and their father, Jitsuo, were killed. Eight boxers from a church boxing league were playing pinball before their matches. They were Masayoshi Higa, 21; Seizu Inamine, 19; Daniel La Verne, 25; Taka Teafuji, 20; Seizo Izumi, 24; Masayoshi Nagamine, 27; Yoshio Tokusato, 19; and Hisao Uyeno, 20, and all the men were killed. Pictured is a store within blocks of the saimin stand.

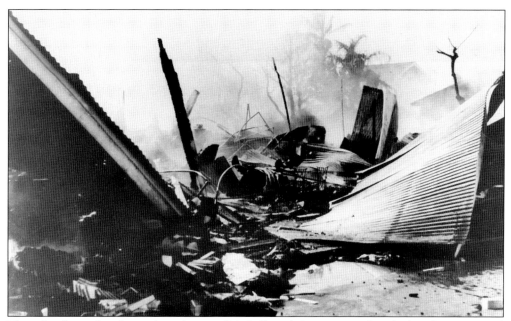

Three fires burned in the residential areas of McCully and King, on Hauoli and Algaroba Streets, and at Lunalilo School, totaling $158,000 in damages to homes and $40,000 to the school. Thirty-one families were displaced, including one of a firefighter who was with his company at Hickam Field.

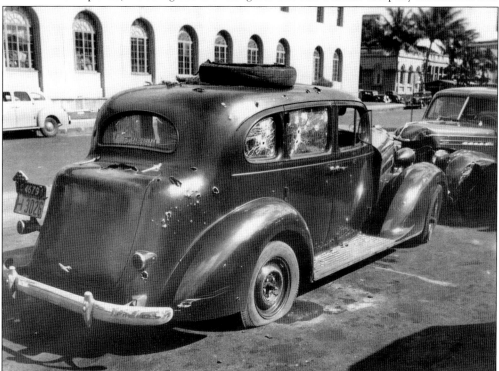

Civilian damage occurred in various locations throughout Honolulu. Sadly, most of the damage was caused by friendly antiaircraft shells hastily fused incorrectly. This photograph shows one of several vehicles in the downtown area damaged that morning.

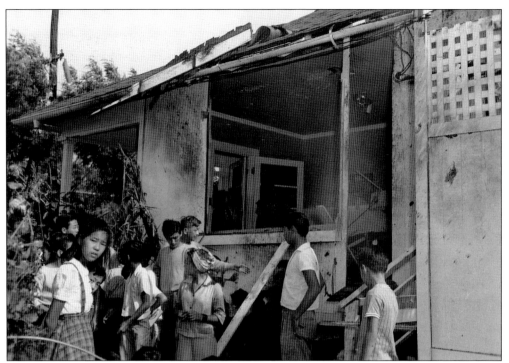

While it was thought incendiary Japanese bombs caused the fires on Oahu, they were caused by US antiaircraft ammunition. Besides the McCully area, there were fires on the Waipahu and Ewa sugar plantations and in Wahiawa, Aiea, and Waialua. This image shows the Goo house in McCully.

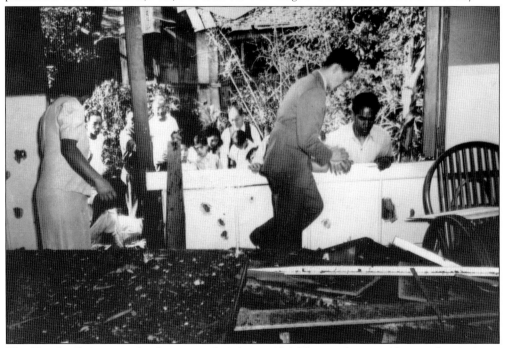

The Goo family inspects the damage to their home. Neighbors gather outside out of curiosity as well as to offer assistance.

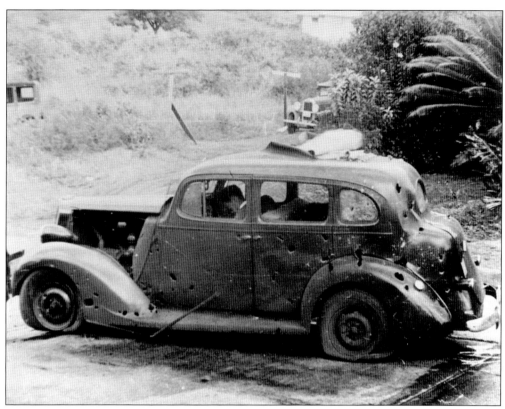

Among the civilian dead were ship riggers speeding to the Pearl Harbor Naval Shipyard. John Adams; his father, Joseph; his uncle Joseph McCabe; and McCabe's nephew David Kahookele were killed when an antiaircraft shell hit their car on Judd Street. Levi Faufata Jr. stood on his porch and watched the car explode, not realizing shrapnel had hit and killed his 12-year-old sister Matilda standing next to him.

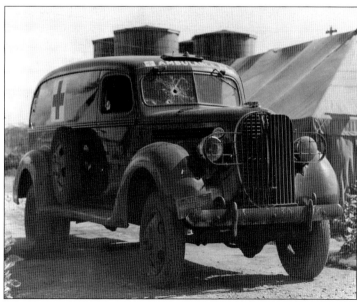

Marine Corps Air Station Ewa, located approximately five miles west of Pearl Harbor, was attacked two minutes before the Pearl Harbor complex. All 48 aircraft were destroyed, with two civilians and two Marines killed. This ambulance shows the nature of the damage at the air station. (NHHC.)

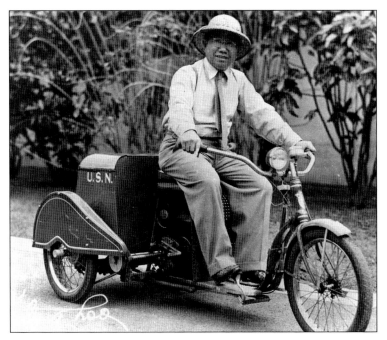

Navy civilian photographer Tai Sing Loo was known for his trademark pith helmet and bright red three-wheeled "putt-putt." On December 7, he was at the Navy Yard gate helping to direct traffic before riding to the attack to photograph it. (Loo took the iconic photograph of Duke Kahanamoku in front of his surfboard.)

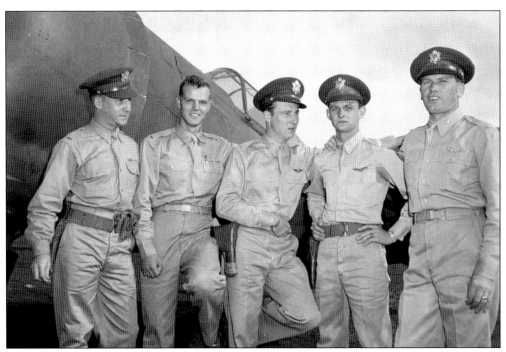

During the attack, 180 US aircraft were destroyed and 159 were damaged. Only 14 American aircraft were able to get in the air. Among those pilots who did get airborne were, from left to right, 1st Lt. M. Sanders, 2nd Lt. Philip M. Rasmussen, 2nd Lt. Kenneth M. Taylor, 2nd Lt. George S. Welch, and 2nd Lt. Harry W. Brown.

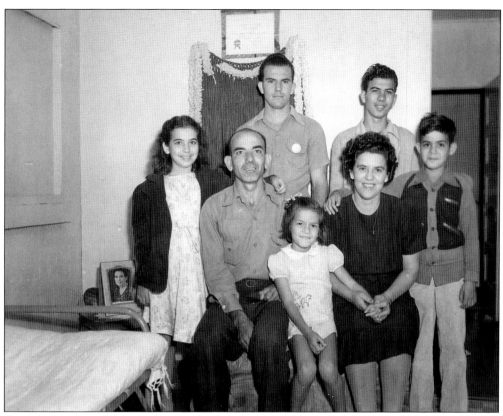

Over the two days following the attack, 32 sailors would be pulled from the hull of the capsized USS *Oklahoma*. Julio DeCastro led his Shop 11 crew to pry off the deck plate to accomplish the rescue. The DeCastro family is shown here. From left to right are (first row) Rose Marie, Julio, Lorretta May, Lydia L., and Richard; (second row) Harold and Julio Jr.

The first shots fired on December 7, 1941, actually came from the USS *Ward* (DD-139), which spotted a two-man Japanese submarine at the mouth of Pearl Harbor. Her gunners, shown here, sank it at approximately 6:15 a.m. It was one of these subs, commanded by Ens. Kazuo Sakamaki, that beached at Bellows Field and was captured by Lt. Paul S. Plybon and Capt. David Akui of the 298th Infantry. Sakamaki was the first prisoner of war taken by the United States in World War II.

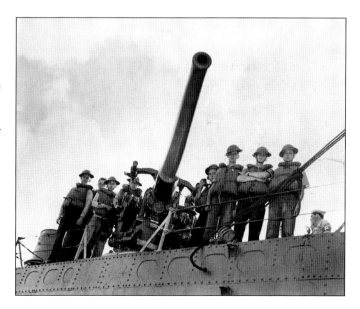

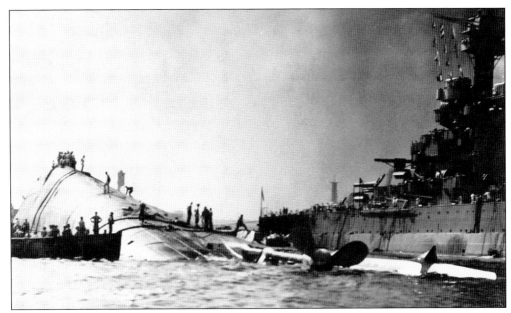

The USS *Oklahoma* (BB-37) is shown on the left, capsized alongside the USS *Maryland* (BB-47) on the right. After rescuing 32 sailors, the armor-plated hull did not permit any further rescue. A total of 429 sailors and Marines remained entombed aboard and tapping on the hull could be heard for nearly three weeks. In 1943, she was finally righted, and the remains were removed and interred. The *Oklahoma* was not returned to service.

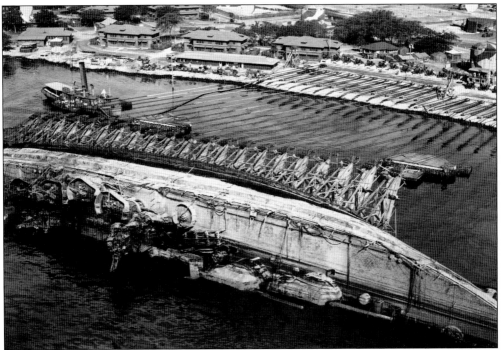

The nearly immediate capsize of the USS *Oklahoma* (BB-37) remains one of the most tragic incidents of the December 7 attack. The salvage operation was complicated, and extensive framing was attached to the hull with cables running to the 21 electric streetcar motors needed to right her. (NPSA.)

Clifford "Moose" Donalson was a member of the Pearl Harbor Naval Shipyard's civilian diving crew. "Moose," a holder of three championship belts in judo and jujitsu, had been diving for three years. At the outset of the war, Pearl Harbor Naval Shipyard was staffed with approximately 50 percent Navy and 50 percent civilian personnel.

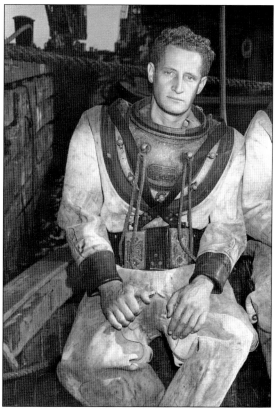

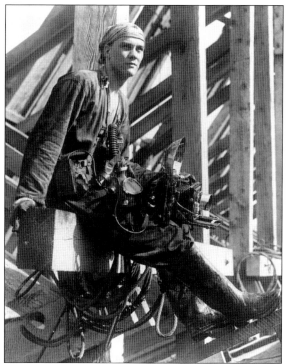

Photographer Mate Third Class T.E. Collins sits atop some of the extensive framing constructed on the hull of the USS *Oklahoma* as part of her salvage and recovery effort in 1943. He was the sole photographer at Pearl Harbor Naval Shipyard for nearly two years and documented most of the underwater devastation. (NHHC.)

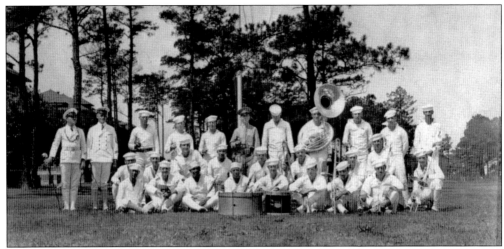

When the attack began, all members of the USS *Arizona* were on the main deck, preparing for colors. They were killed manning the ammunition hoists on the third deck. Contrary to myth, they did not participate in the Battle of Music the night before. They came in second behind the Marine Barracks Band during the semifinal round. The final round never took place. After the war, the trophy was awarded posthumously to the *Arizona* band.

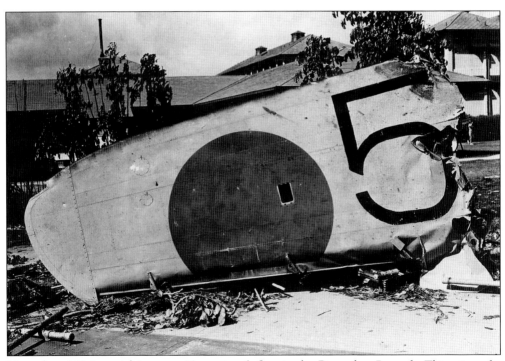

More than 350 Imperial Japanese Navy aircraft flew in the December 7 attack. This wing of a Nakajima B-5 Kate bomber at the Pearl Harbor Naval Hospital is the remains of one of only 29 enemy aircraft that were shot down.

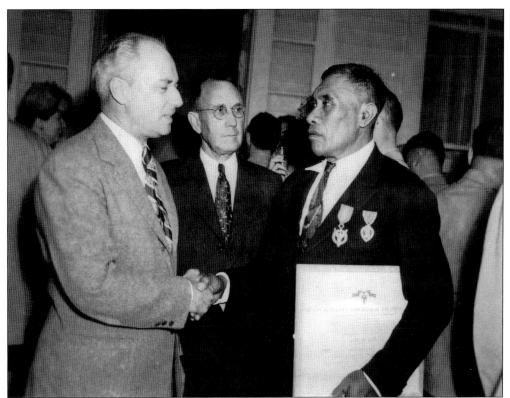

On December 7, a damaged Japanese Zero fighter was forced to land on the privately owned island of Niihau inhabited by native Hawaiians. The pilot attempted to intimidate the inhabitants with the aircraft machine gun and was subdued by Benjamin Kanahele, the Niihau farm foreman. Here, Kanahele, on the right, receives the Purple Heart medal and Medal of Merit from Representative Farrington, on the left, for his actions. In the center is Lawrence Judd, former governor and head of the Office of Civil Defense, who acted as Kanahele's Hawaiian language interpreter.

Before the war, the Japanese Hospital was operated mainly for and by alien Japanese. After the attack, the Army took it over, and it was reorganized and renamed Kuakini Hospital (named after John Kuakini, adviser to Kamehameha I.) Here, Army nurses are shown leaving a covered air-raid shelter at Kuakini.

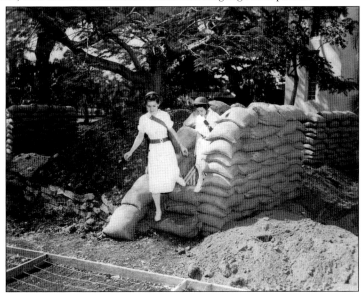

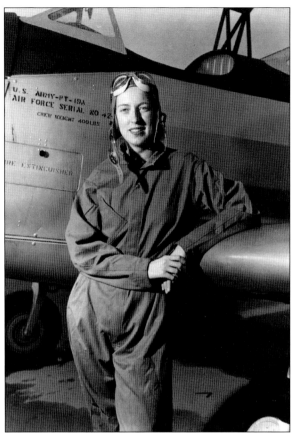

Flight instructors Tommy Tom, Margurite Gambo, and Cornelia Fort were giving flying lessons on December 7, 1941. Roy Vitousek had his son in his plane, and two soldiers took out Piper Cubs. All the aircraft landed safely. When the Japanese strafed the Honolulu Airport, they hit a Hawaiian Airlines D-3 and killed a civilian. In 1942, Fort joined the Women Airforce Service Pilots and was killed in a midair crash during a routine flight.

Mess Attendant Second Class Doris Miller received the Navy Cross from Adm. Chester W. Nimitz at an awards ceremony held on the flight deck of the USS *Enterprise* (CV-6) at Pearl Harbor on May 27, 1942. The medal, second only to the Medal of Honor, was awarded for heroism on board the USS *West Virginia* (BB-48) during the Pearl Harbor attack on December 7, 1941.

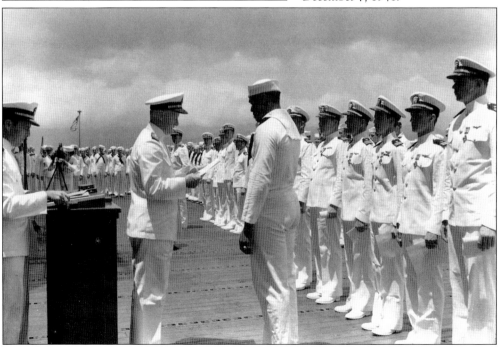

Two

WINDS OF WAR

More than a year before the attack, the people of Hawaii saw the signs of war. On May 23, 1940, the government ordered a territory-wide blackout practice. That same month, the Red Cross began teaching first aid classes and making plans for the Women's Motor Corps (ambulance drivers). In February, the Hawaii Sugar Planters' Association drew up a specific list of crops to grow in case the shipping lanes were blockaded.

In April 1941, General Short urged the community to prepare for the possibility of an invasion by producing and storing food. In May 1941, there was a second territory-wide blackout practice. In June 1941, the first donation was collected at Hawaii Blood-Plasma Bank. In June 1941, General Short announced plans for an underground warehouse able to store 15,000 tons of food to feed Oahu residents for three months. (At Pearl Harbor, there were cold storage plants storing thousands of pounds of perishable food.)

In July 1941, the government distributed pamphlets informing residents about sabotage; air, sea, and surface attacks; and enemy landings. In July 1941, the Hawaii Sugar Planters' Association organized a police force made up of employees trained to work under the Honolulu Police Department. In August 1941, six mobile radar stations arrived in Hawaii. In September 1941, Admiral Kimmel addressed the Honolulu Chamber of Commerce that it must "face the realities" of the possibility of war.

In October 1941, the Honolulu Rapid Transit Company extended its lines to Pearl Harbor, and all National Guard units were called to active duty. That same month, the Navy filed suit to condemn 117 acres in Pearl City to enlarge the Pearl Harbor Naval Station. In November 1941, the streets in Honolulu were all designated one-way to make emergency traffic run smoother.

So, on December 7, 1941, when Web Ebley screeched over the radio, "This is the Real McCoy!" Hawaii residents may have been shocked by the air attack, but they had been preparing for a sea attack for two years.

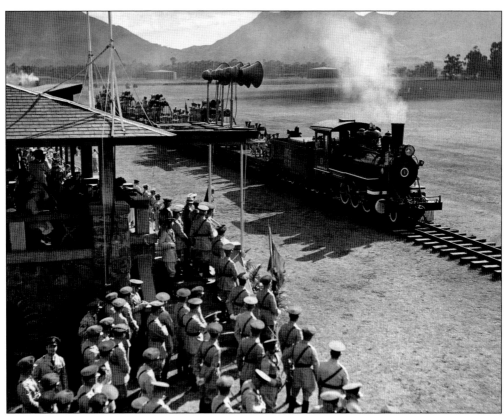

The US Army strategists participated in the development of Hawaii's sugar plantation rail system as well as the system at the port. They planned that in the event of an emergency, the hundreds of miles of rail could be appropriated to support mobilization. This photograph shows the Hawaii Army garrison reviewing a new locomotive on a new sugar plantation spur in 1939. (HSA.)

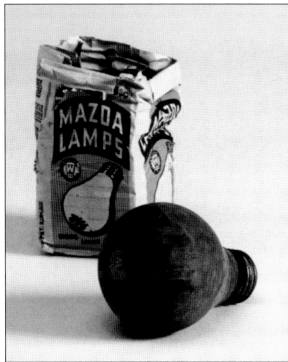

In May 1940, there was a territory-wide blackout drill. There was a second in May 1941, and a third was scheduled for January 1942. From 6:00 p.m. to 6:00 a.m., no lights could show, and no one without a blackout pass was allowed on the street. After the attack, General Electric produced Mazda Lamps blackout bulbs; they had a one-inch circle at the top to allow a small bit of light to show.

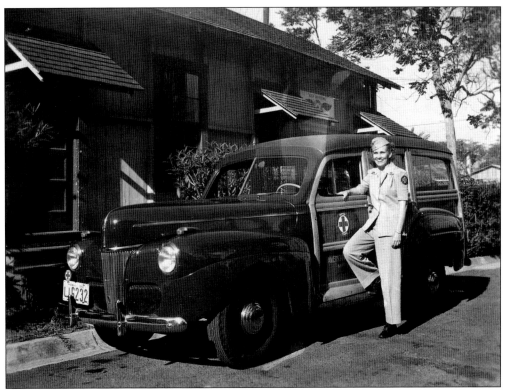

The American Red Cross Motor Corps women volunteers were trained in auto mechanics; first aid, including the emergency delivery of babies; driving in black-out conditions; and for a gas attack. The American Red Cross Motor Corps was one of the first volunteer organizations of the Red Cross, established in May 1940.

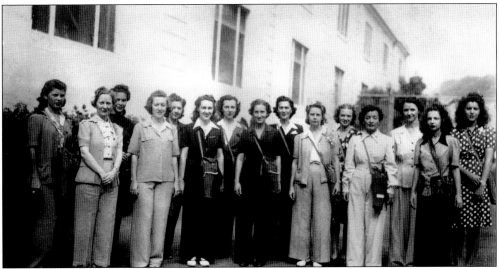

Women employees of the Selective Service Headquarters of Honolulu pose. From left to right are Edna M. Ryan, Eleanor F. Wilson, Blanche Porter, Dora Pelletier, Irene Gilmore, Sally Palmer, Lillian Chapson, Dorine Haglund, Mary Jane Scott, Betty Osborne, Mary Stevenson, Elizabeth Knight, Nettie Bruns, Angeline Crosby, and Adaline Johnson.

Another system of civilian transportation to the smaller cantonments was by bus. These workers are boarding at the end of their shift.

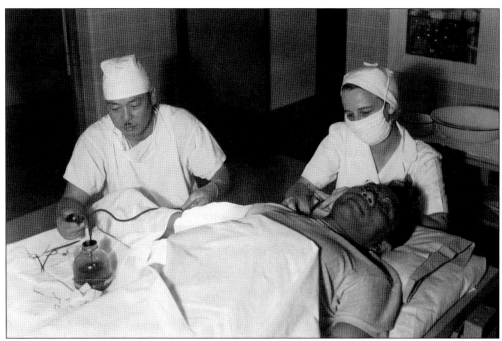

In December 1940, Dr. Eric Fennel presented his final report at the public health committee of the chamber of commerce "on the need for a blood-plasma bank to recognize the wider exposure of civilians to trauma in war time." The recommendation was approved. In June 1941, the first blood donation was collected.

In April 1941, General Short urged the community to prepare for the possibility of an invasion by producing and storing food, organizing an emergency corps of doctors and nurses, establishing a police auxiliary, drawing up a plan of evacuation of women and children from areas of possible bombardment, and the constructing of bomb shelters. Here is a demonstration of building a bomb shelter in a backyard.

By 1940, the food supply was a concern due to the increase in defense workers and military personnel. In July 1940, the mayor appointed a committee to analyze food requirements. They concluded that Oahu produced only 15 percent of its food needs and stored only a 45-day supply of imported food. The government encouraged families to grow vegetables, chickens, and rabbits to independently sustain themselves.

31

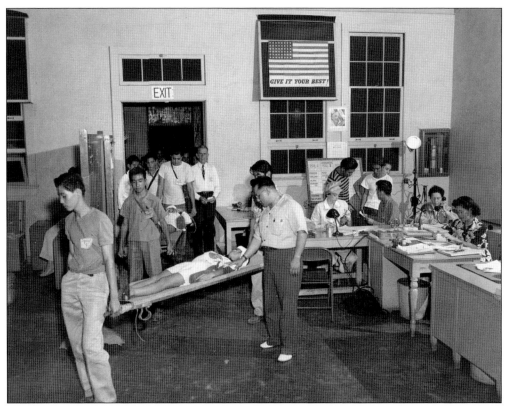

In 1941, planning by the Major Disaster Council developed contingencies for the safe evacuation of patients from hospitals vulnerable to attack to selected schools and had trained and equipped more than 4,600 first aid unit volunteers to staff those facilities. Here, high school students are being trained for that task.

The night before the attack, Christmas lights were ablaze on King Street, ready for holiday shoppers. The chamber of commerce expected a boom holiday season with thousands of war workers and tens of thousands of military living in Hawaii. The signs were clear. Between June 1940 and June 1941, the retail trade was up $31 million. The next time Christmas lights were allowed was in 1945.

Three

MARTIAL LAW

When territorial governor Joseph Poindexter authorized martial law on December 7, 1941, he expected it to be in effect for several months. He never foresaw it extending through October 1944.

In 1942, Poindexter openly regretted his decision that suspended nearly every civil liberty of the islands' residents and turned Hawaii into an armed military camp. More than curfew, blackout, and rationing, every Hawaii resident was required to be registered and fingerprinted—the only mass fingerprinting in the history of the United States. On Oahu, a 600-square-mile island, one-third was under military control. Lands, long rented or owned by farmers and families, were declared "condemned" and were used by the military for various reasons. Forty thousand people were relocated. Schools, hotels, government buildings, and even Iolani Palace were taken over. In downtown Honolulu, sandbagged machine-gun nests were posted on rooftops, and streets were armed with military police controlling traffic.

German, Italian, and Austrian citizens were interned based on nationality, and selected Japanese living on the islands were detained. An internment camp at Honouliuli was built that contained both internees and prisoners of war. All media and personal mail were censored, and any speech, words, gestures, songs, plays, pictures, or banners that exhibited hostility or disrespect to the United States was forbidden. Absenteeism from work was a crime, and workers were not allowed to quit their jobs. Prices were set—everything from major purchases to the price of a pound of ground beef to a souvenir photograph with a hula girl.

Under martial law, civil and criminal courts were taken over by the Army. The civil courts were permitted to reopen by March 1942, but they were limited to handling cases of divorce and property claims. Trial by jury was forbidden, with the Army claiming multiracial juries could not be impartial. (The writ of habeas corpus remained suspended until 1944.) A single Army officer (typically a junior officer with little or no legal background) became judge and jury and meted out sentences during a procedure that took an average of less than five minutes.

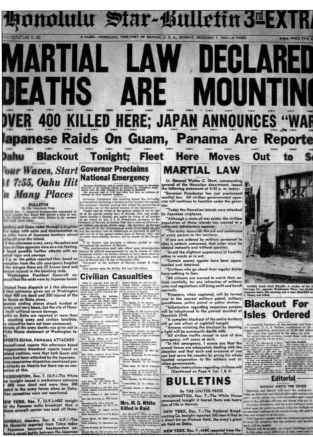

At 11:30 a.m. on December 7, 1941, Governor Poindexter was on the phone with President Roosevelt. Martial law was declared. All civilian courts and law enforcement would come under the jurisdiction of the US military. Among other elements were that price controls were enacted, censorship was imposed, food was controlled and regulated, the evacuation of citizens was ordered, and government land was taken over. (HSA.)

The entire shoreline of Oahu was protected against amphibious invasion with barbed wire, although at Waikiki, pukas (holes) were opened for swimming that were resecured half an hour before curfew. Here, with Diamond Head in the background, people enjoy the beach in front of the Moana Hotel.

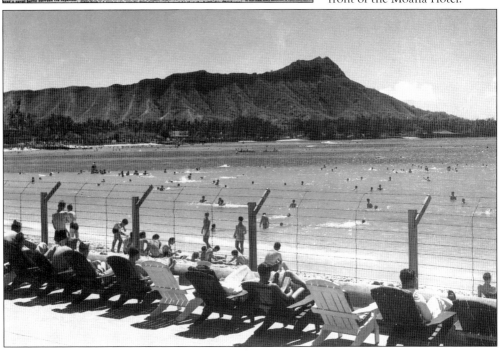

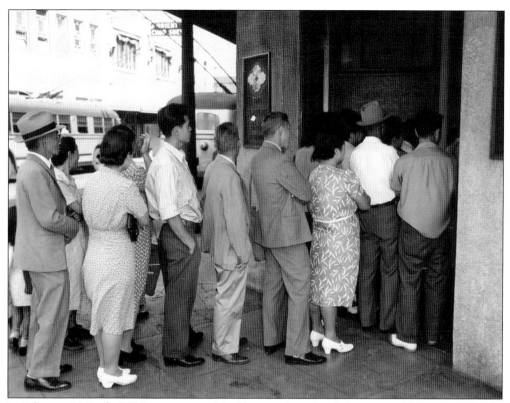

In February 1942, the US Department of the Treasury liquidated the assets of the Japanese banks Yokohama Species, Pacific Bank, and Sumitomo Bank, including their deposits. Eventually, the government returned the assets of depositors who were US citizens or deemed non-enemy aliens, but many Japanese-born customers were denied the return. (JCCH.)

Within three hours of martial law being declared, 370 Japanese and 104 suspects were apprehended as enemy aliens by the Federal Bureau of Investigation (FBI). Virtually every German, Italian, and Austrian citizen were detained except the elderly and infirmed. Among them were Norwegian composer and Honolulu Symphony Orchestra cofounder Alf Hurum and the Austrian-born architect Alfred Preis, who would later design the USS *Arizona* Memorial in Pearl Harbor.

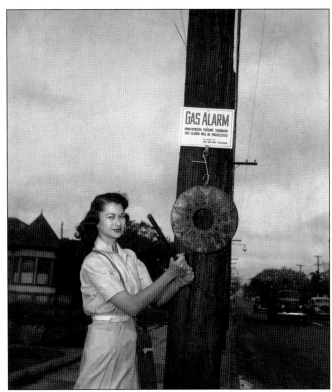

Marjorie Carter demonstrates one of Honolulu's 1,500 gas alarms that were erected by the Office of Civilian Defense. Like most gas alarms, it was made of an automobile brake drum and a lead pipe. They were hung on public utility poles at 1,000-foot intervals. In addition, volunteers were trained in cleaning and treating persons exposed to war gases.

Margaret (Kamm) Cummings is ready to fill her emergency evacuation knapsack. Some of the suggested articles included prescription medicines, cans of Spam, tea bags, chewing gum, bars of soap, matches, canned vegetables, and feminine hygiene supplies.

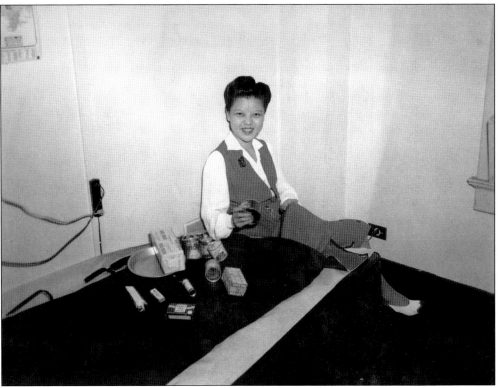

Immediately after the attack, Hawaii was defined as a war zone, and all families of servicemen were ordered to return to the mainland for their safety and to ease the food shortage. By May 1942, about 30,000 (including civilian residents) left Hawaii. Priorities for evacuation were pregnant women, the sick, tourists caught in Hawaii, women with several children, women with few children, and childless women. Here, women crowd the steamship office to make their arrangements.

Under martial law, all mail was censored. Civilian women were hired to cut out any references to military information, weather, construction, or damage or injuries caused by war. Even sketches and doodles were cut out. A censor's stamp and blue tape sealing the envelope were required before posting.

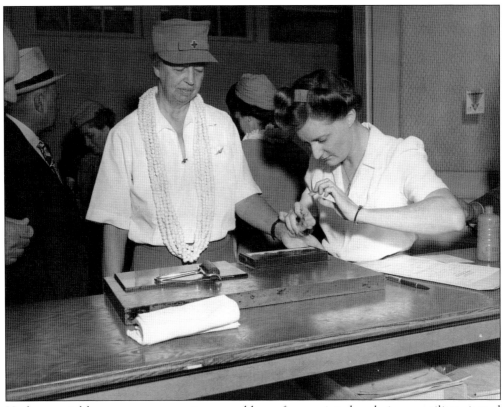

Under martial law, everyone over six years old was fingerprinted and given a military-issued identification card, which they were required to carry at all times. No one was exempt, not even First Lady Eleanor Roosevelt when she visited Oahu in September 1943. Here, Julia Wilson of the Office of Civilian Defense is registering First Lady Roosevelt. During her stay on the islands, the first lady visited hospitals, volunteer organizations, and troops in the field.

Because adult gas masks were too big for children, the "Bunny Mask" was specifically designed to fit infants and toddlers. This dual-layered mask featured an eye window and a secure drawstring closure around the child's face. The outer bag was made of denim infused with CC-2 (chloramide powder) in paraffin, while the inner muslin bag was impregnated with paraffin. The eyepiece was fashioned from scrap celluloid sourced from old X-ray negatives.

Lieutenant Doty urges Donna Lee Dohlen to wear her mask. Behind Dohlen is Beatrice Carter, principal of Kapalama School. Of the 477 masks allocated to the school, all but 20 fit. The US Army called for volunteers to adjust adult gas masks to fit children by sewing towels and sponge-rubber inserts for padding.

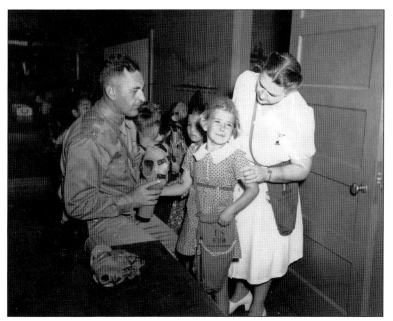

Drills became a way of life in Honolulu early in the war, and they continued well into 1944. Participation was mandatory, including shop owners and civilians on the street. The simulated gas attack shown in this photograph further illustrates the impact on the businesses along the routes of evacuation.

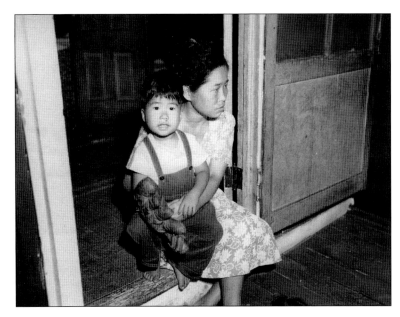

Here, Mrs. Shinichi Yosuda and her son Richard wait for orders to leave their Upper Manoa home, which was condemned as a site to build emergency housing for federal workers' families. During the war, one-third of Oahu was used for military purposes by evicting, evacuating, or leasing land, business, and public buildings.

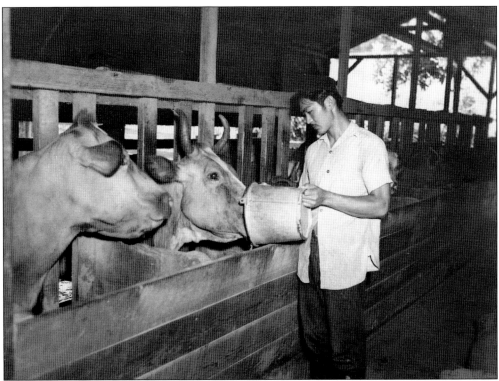

On May 11, 1945, about 150 people received formal notices that the land they had been living on was condemned and leased to the federal government to build houses for the families of civilian war workers. Residents were forced to sell their livestock and abandon their vegetable farms. Charles Matsunaga, shown feeding some of his 46 cows, had to tear down all his buildings and attempt to relocate all his cows.

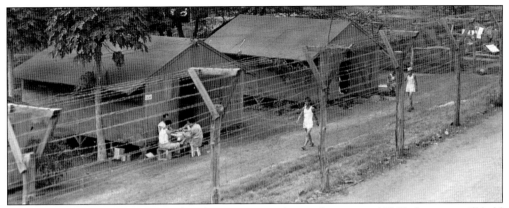

The number of internees decreased as the war went on, but in the spring of 1945, the camp still held 34 Japanese male aliens, including four minors and 10 female Japanese aliens, of which five were minors and six were foreign-born Japanese. Even in September, after the war was over, Honouliuli still held 22 men. By then, the camp was occupied by 4,000 prisoners of war. (JCCH.)

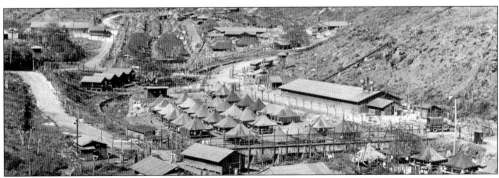

Although its total population capacity was 3,000, at its peak, Honouliuli held 320 internees. During the course of the war, 600 US citizens, more than 90 percent American-born Japanese, were interned in the camp. Within Honouliuli was a confinement area for prisoners of war. (JCCH and HPV.)

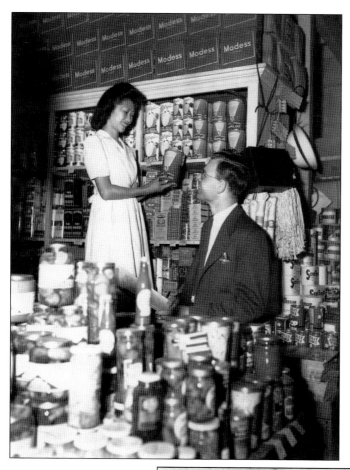

The Office of Price Administration (OPA) set the price for everything from paper clips to rent to blackout bulbs and even tattoo work. OPA censors routinely checked stores and service businesses to ensure their prices were not over the price limit. In the OPA price schedules of 1942, only 14 violations were prosecuted. A wholesale dairy business was fined $2,500 for overcharging. (HSA.)

If the Japanese invaded Hawaii and confiscated US dollars, they could use the money in international markets. To avoid that, the government collected all paper currency ($200 million) and burned it in the Nuuanu Cemetery crematorium and the Aiea Sugar Mill in July 1942. That currency was replaced with dollars stamped "Hawaii," making it valid only within the territory. Those dollars were used through 1944 when the "Hawaii" currency was exchanged for regular US dollars.

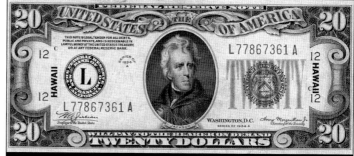
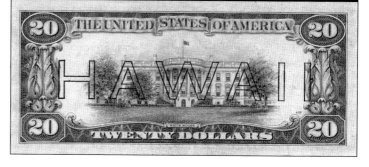

On December 7, 1941, saloons were closed, and the sale of liquor, except liquor sold under a doctor's permit, was illegal. Most doctors issued less than five permits, but three doctors issued more than 400. One was given a five-year prison sentence (but was released on parole within a year). Due to public outcry, bars reopened in February 1942.

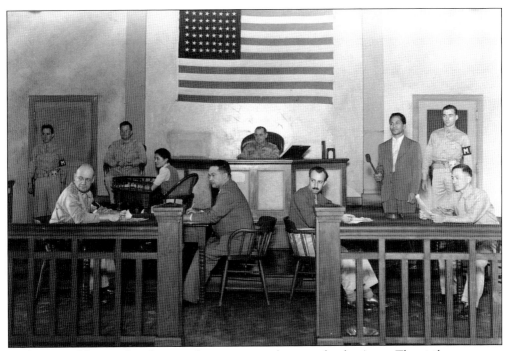

Under martial law, civil and criminal courts were taken over by the Army. The civil courts were reopened by March 1942 but were limited to cases of divorce and property claims. Trial by jury was forbidden, with the Army claiming multiracial juries could not be impartial, and the writ of habeas corpus remained suspended until 1944. A single Army officer (typically a junior officer with little or no legal background) became judge and jury and meted out sentences during a procedure that took an average of less than five minutes. (HPV.)

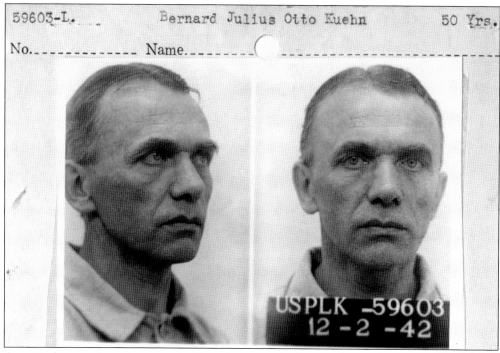

Otto Kuehn was the only person in Hawaii convicted of spying for the Japanese. A member of the Nazi party, Kuehn was arrested on December 8, confessed, and was sentenced to death "by musketry." But fearing retaliation against American prisoners of war by the Germans, the United States commuted his sentence to 50 years of hard labor, which he never served. He was held at Ellis Island until 1948 when Kuehn was voluntarily deported to Argentina.

In the Supreme Court case *Duncan v. Kahanamoku*, a decision was made that martial law did not include the power to supplant civilian courts with military tribunals. Duke Kahanamoku, a military police officer, arrested Lloyd C. Duncan, a civilian shipfitter, on February 24, 1944, after Duncan brawled with two armed Marine sentries. Duncan was tried and convicted of assault with the intent to resist. Duncan is shown on the right.

Four

WAR ZONE

Following the December 7 attack, it would be easy to argue the Hawaii Territory was part of the Pacific war zone until the summer of 1942. The residents of the islands no doubt felt a part of a war zone as boundless military construction took place throughout the territory and well over a million uniformed military personnel transited through Hawaii for training and staging for the Pacific islands campaign.

Construction of civilian cantonments housing thousands of contractors, barracks, wharves, dry docks, hangars, training areas, roads, and other infrastructure disrupted normal life beginning in 1939. Nearly every square acre of available land was used to accommodate the crush of people. Local civilians left their normal employment in business and agriculture to join the ranks of construction workers and government service.

Barbed wire, machine-gun positions, sentries, and other obstacles were erected along the beaches of the islands to deter the potential for amphibious attack. Sentries were placed at all critical infrastructure such as bridges, power plants, Hawaii's sole refinery, telephone exchanges, and coastal roads. Large antiaircraft weapons were placed throughout Oahu, often close to neighborhoods, schools, and churches. Because the active-duty forces were required to prepare for the Pacific campaign, the Hawaii Territorial Guard was created to fulfill many of these functions. They were not part of the military per se but fell under the direction of the Office of Military Government. Other distinctive volunteer militias were created to accomplish additional specific functions on all islands. Once training began in earnest, live ordnance could be heard on all islands as aircraft, artillery, infantry weapons, and naval guns bombarded the impact areas.

Rail lines were constructed to transport civilian contractors to their cantonments. Additionally, the military appropriated the sugar company rail systems, plantation camps, cane fields barracks, and schools as their needs and footprint continued to grow.

Hawaii was thrust into a war zone that resonated with the people raised there in more idyllic times, especially youngsters who were required to participate in air-raid drills, gas masks, fingerprinting, evacuation drills, and blackouts. Their experiences left a unique perspective on war and changed the future as Hawaii transitioned into statehood.

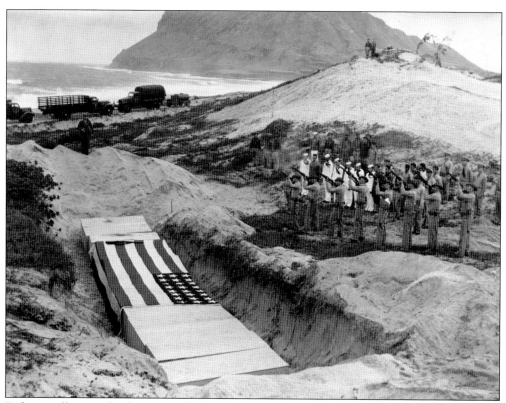

Eighteen officers and sailors were killed at Naval Air Station Kaneohe. Here, a Marine rifle squad fires a 21-gun salute over the bodies of 15 of the men buried in a temporary grave at Mokapu peninsula, where the air station is located, on December 8.

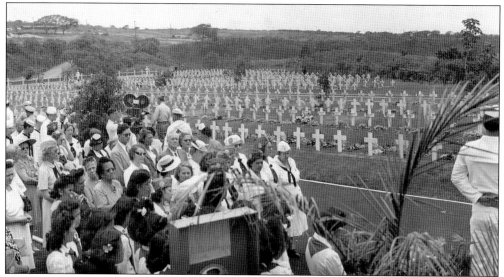

The temporary graves of servicemen were taken care of by local garden clubs. The bodies of the deceased were returned to the mainland through the military's burial program using Army transport vessels. The first transport was by the *Honda Knot*, carrying the coffins of 3,028 individuals from Pearl Harbor to San Francisco Bay in October 1947.

Fearing Japanese fishermen would transport enemy personnel or communicate with enemy subs, the Department of Justice impounded all alien-owned vessels in February 1940. At the time, there were 450 Japanese sampans, some up to 80 feet long with a range of 1,500 miles. The Navy converted most of them into patrol boats or utility craft. Since these boats accounted for 70 percent of the catch in the islands, their deactivation cut the available fish supply. (HSA.)

This postcard was sent by Robert Willis to June Staley less than a week after the Japanese attack on Pearl Harbor. These postcards were an effort to notify their loved ones of their status. The member was required to cross off statements that were inapplicable. Luckily, Willis indicates that he survived the attack without major injury. (WWM.)

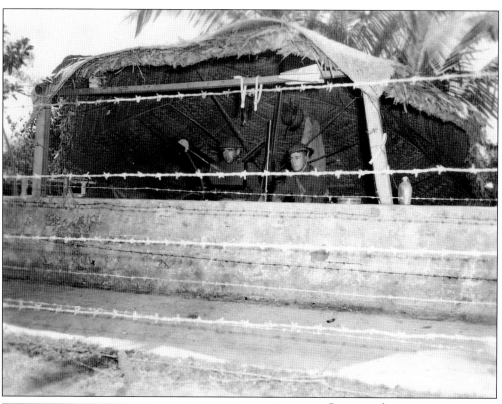

Owing to the concerns over the possibility of a follow-on invasion of the Hawaiian islands, the coastlines were protected by Army garrison soldiers. Machine-gun positions like this one were manned 24 hours a day, seven days a week for nearly the first two years of the war.

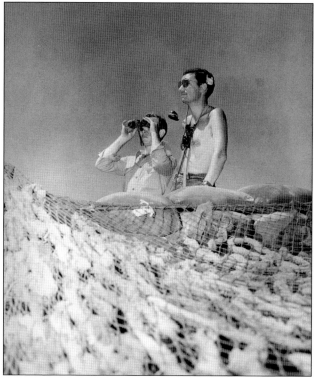

The Hawaii National Guard provided most of the active-duty security along the beaches and coasts of the islands. These two coast watchers maintain part of that 24-hour-a-day, seven-days-a-week vigil. This lasted well into 1944.

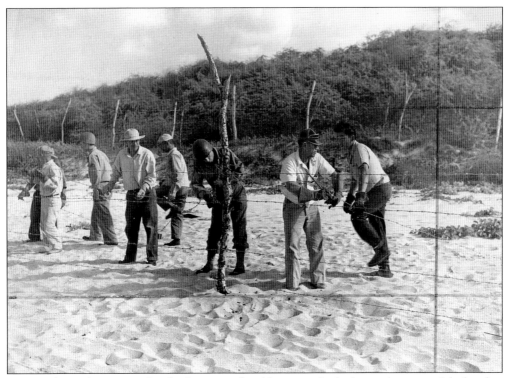

Here, civilian volunteers under the direction of a soldier string barbed wire along one of the beaches of Oahu. Because of the vulnerability most beaches posed to potential invasion, civilian volunteers were recruited to accomplish this monumental task.

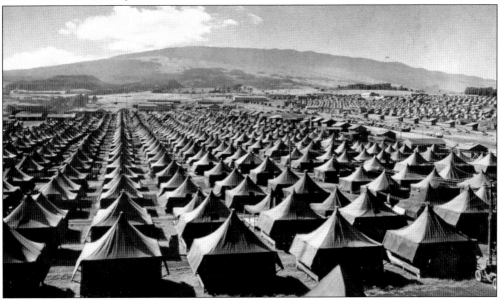

The Fourth Marine Division staged and trained for combat on the island of Maui. About 18,000 Marines used nearly 45 different sites on the island to prepare for the invasion of Saipan. Following that battle, the division returned to Camp Maui to restore itself, muster replacements, and train for the Battle of Iwo Jima. This photograph shows the division's bivouac area.

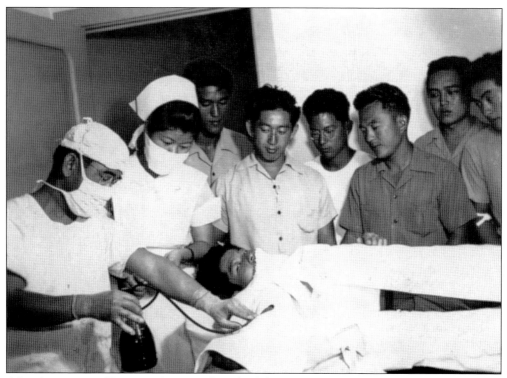

After Americans of Japanese Ancestry (AJAs) of the Hawaii Territorial Guard were discharged without warning, they petitioned the governor to serve and were accepted as a civilian labor battalion to be attached to the 34th Combat Engineers Regiment. They quarried rock, strung barbed wire, and built military installations. Varsity Victory Volunteers (VVV), as they called themselves, were a major stepping stone in the creation of the 442nd Regimental Combat Team. Here, a VVV member gives blood as his pals look on.

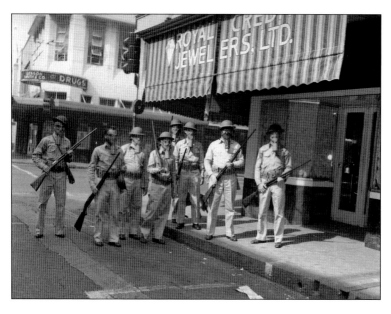

Here, members of the Businessmen Military Training Corps (BMTC) respond to a simulated incursion in the downtown area. The BMTC membership was limited to Caucasians and part Hawaiians and included many prominent businessmen. By the end of January 1942, it comprised 1,500 men in 17 companies.

The Hawaii Territorial Guards, here on the capitol steps, were organized and activated on December 7. From the top left, down and up, are Charles Spencer, Noboru Tsue, Paul Kim, Joseph Gonsalves, Wallace Chang, Stanley Martin, and Richard Tracy.

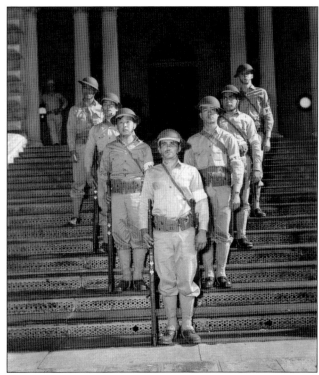

By the fall of 1942, some 1,500 men formed the Hawaiian Air Depot Volunteer Corps to help at Hickam Field with anti-sabotage efforts, firefighting, civilian evacuations, and guard duty. They were the only volunteer group to be issued antiaircraft weapons.

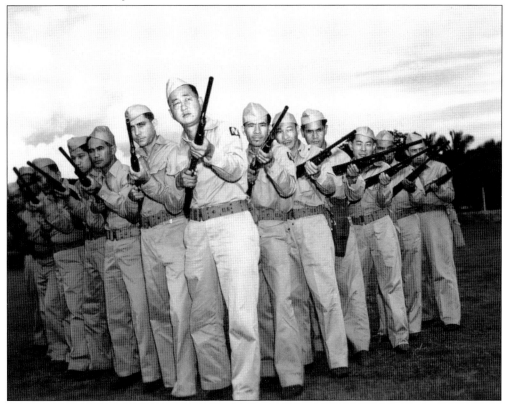

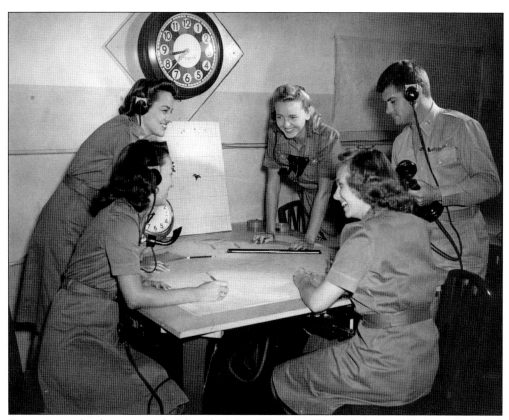

Operating under the command of the 7th Fighter Wing, the Women's Air Raid Defense (WARDs) replaced soldiers who were air traffic plotters. WARDs were responsible for plotting the trajectories of all aircraft, distinguishing between "friend" and "foe," and identifying distressed aircraft. They had the authority to declare air-raid emergencies and engaged in drills simulating enemy attacks. The WARDs, known as "Shuffleboard Pilots," were sequestered at Fort Shafter, Oahu, and remained operational through September 1945.

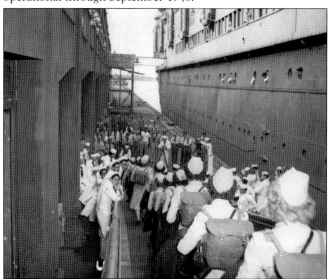

On January 6, the first large contingent of Women Accepted for Voluntary Military Service (WAVES) to report for duty outside the United States arrived in Pearl Harbor. Sailors on duty in Hawaii gather at the foot of the gangway to welcome the WAVES.

The first company of the Women's Army Corps arrived in Hawaii in March 1944 and was assigned to administrative and motor transport duty. The War Manpower Commission refused to clear Hawaii women to join the military because most held essential jobs in war service. In October 1944, that restriction was lifted, and 59 territory women were accepted for service. (Note the Aloha Tower with camouflaged paint.)

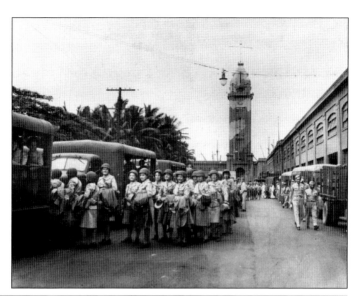

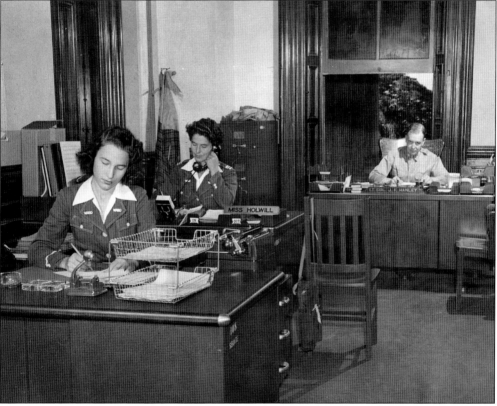

Established in August 1942, the Women's Army Volunteer Corps (WAVC) was initiated with the objective of training women for noncombat roles. These women underwent Army basic training, including field bivouacs, and subsequently assumed responsibilities such as stenographers, bus drivers, and tax assessors, replacing men and freeing them to fight. The largest unit supported the Army Corps of Engineers at Punahou School. From left to right are WAVC Barbara Rohr; WAVC Marjorie Breffeilh; and Col. J.F. Hanley, Judge Advocate General's Corps.

Japanese military action continued in Hawaii after December 7. On March 4, 1942, a Japanese floatplane attempting to bomb Pearl Harbor got lost in the weather and dropped its bombs less than 300 yards from Theodore Roosevelt High School. The soldiers here are inspecting one of the four craters near the campus.

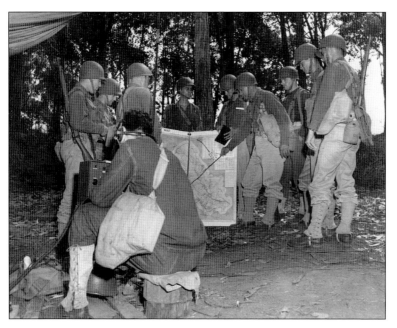

Military training was conducted 24 hours a day throughout the war. In this photograph, the patrol leader is briefing an exercise. Note the map of Oahu, which has become part of the "objective" in the exercise.

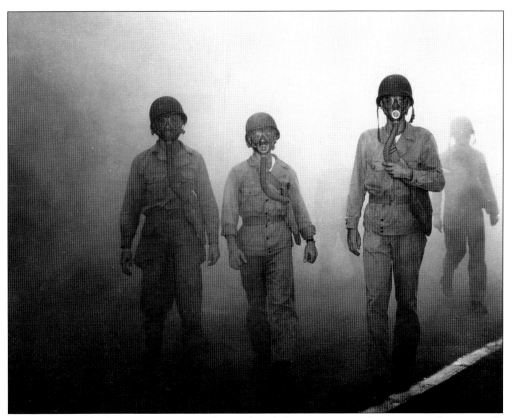

Training for both the Hawaii Territorial Guard and the numerous volunteer units began nearly immediately following the Japanese attack. Here, guardsmen undergo gas mask training at Bellows Field. Gas masks were mandatory for everyone in Hawaii until 1944.

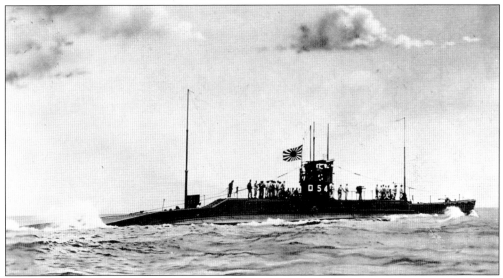

Japanese submarines like this one plied Hawaiian waters throughout 1942. They conducted nuisance raids at the harbors on Hawaii Island, Maui, and Kauai. Fuel tanks, piers, and radio towers were damaged.

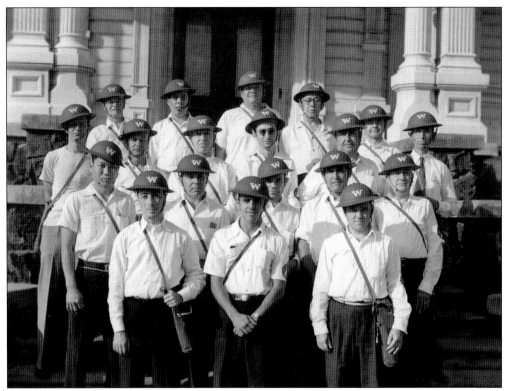

Civil defense wardens associated with the *Honolulu Star-Bulletin* are, from left to right, (first row) Manuel Gomes, David Cordeiro, and Ralph Rerex; (second row) Walter Cho, Manuel Joseph, Frank Matthys, A.P. Gomes, and Ben C. Stearns; (third row) Alex Soares, Charles Teyes, Charles Treu, Walter R. Johnson, Manuel Bisho, and Lenley Hawksworth; (fourth row) William Ham, Joseph Bomes, Ernest Stenberg, Abel Nascimenia, and Riley H. Allen.

Pictured is an early photograph of the Maui Rifles, one of the Island Defense Volunteer groups. This photograph is prior to their having their unique shoulder patch. Each volunteer defense group had a distinctive shoulder patch by the war's end.

Many of the defense volunteer organizations formed competitive marksmanship teams, such as the shotgun team of the Hawaii Air Defense Volunteers shown here. Pistol and rifle teams often competed at the military ranges on Oahu and neighboring islands.

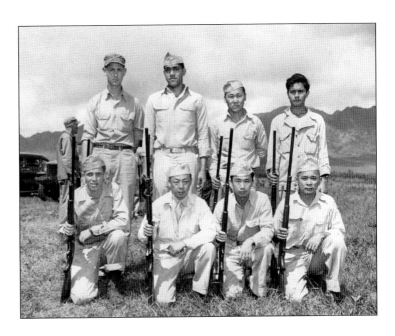

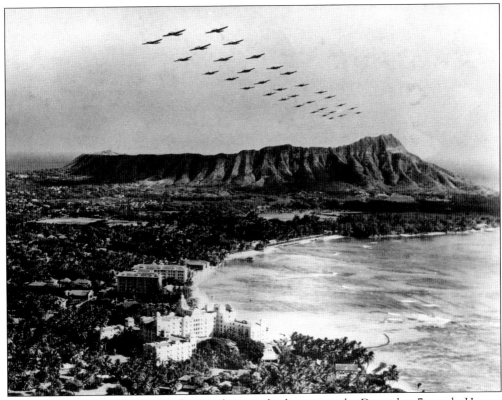

Military exercises were commonplace in the years leading up to the December 7 attack. Here, a flight of B-18 bombers, passing over Diamond Head and Waikiki, are clearly in a formation for the benefit of the local populace. The B-18 was replaced in Europe by the B-17, but it remained in service in Hawaii for a time flying anti-submarine missions. (NPSA.)

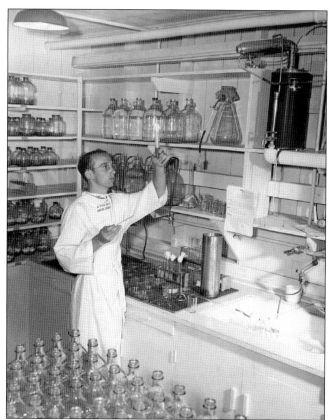

Through 1943, penicillin production was the War Department's second priority after the Manhattan Project. The Penicillin Laboratory at Aiea Naval Hospital cultivated penicillin in gauze pads in bottles and then stored the culture on shelves. Aiea Hospital was the largest American military hospital outside the continental United States.

Pvt. Charles W. Pernot lost his left arm during the Battle of Tarawa. As part of his therapy, he is weaving a cellophane handbag. The Occupational Therapy Association of Hawaii trained 40 volunteers to serve as assistants in various therapeutic activities. Therapy programs included activities such as weaving, wood carving, metalwork, leatherwork, and toy making.

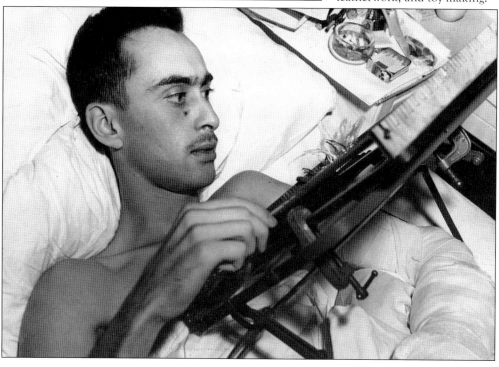

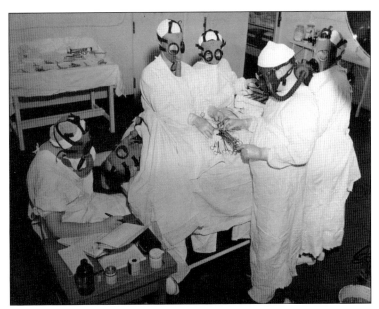

A medical team at an Army hospital demonstrates how an appendectomy would be performed using gas masks. From left to right are 2nd. Lt. Ida Chernes, Lt. Col. Arnold Jensen, 2nd. Lt. Willene Byrd, Capt. Ken Mooney, and 2nd. Lt. Dorothy Dozier with a patient.

In December 1941, the "Christmas Tree Ship" delivering trees from Oregon was ordered home after the attack on Pearl Harbor. Due to inclement weather and radio silence, the ship beached, spilling its cargo of 60,000 Christmas trees, 10,000 frozen turkeys, 3,000 frozen chickens, and thousands of cases of prime steaks. That year, many Hawaii families cut down Norfolk and Cook pine trees to use as Christmas trees, a tradition that continues today. Shown is a Norfolk pine Christmas tree at the Navy Hospital.

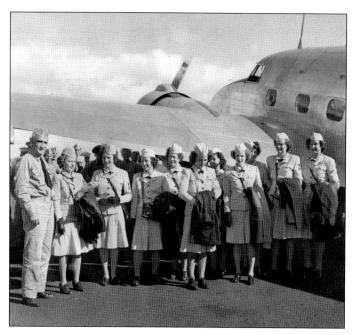

Capt. J. Cotton, US Navy, commander of Naval Air Station Puunene, Maui, welcomes the first group of WAVES. Captain Cotton, left, is greeting Chief Yeoman Vera M. Pearson, Aviation Machinist Mate First Class Lee Snyder, Sp2c. Judith McFarland, Yeoman Second Class Edith M. Pyper, S1c. Effie Helen Scott, Radioman First Class Lorraine Pellaton, S1c. Mary Pchelka, Radioman Second Class Colleen M. Luken, Yeoman Second Class Hertha Ramsey, and S1c. Mary L. Schoell.

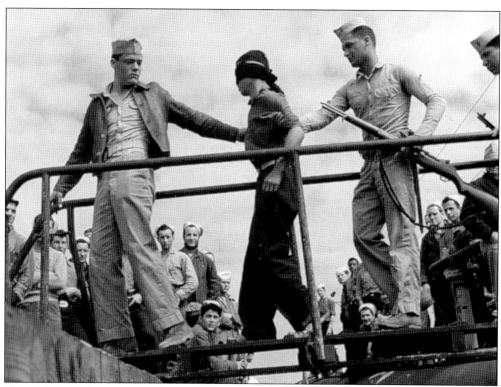

Hawaii became the early site for many captured Japanese prisoners of war (POW), particularly those captured at sea from ships sunk during naval engagements. This prisoner is being escorted from a US submarine at Pearl Harbor. In addition to Honouliuli, POW camps were established at other locations, one of the largest being Marine Corps Air Station (MCAS) Ewa.

Five

DAILY LIFE

A wartime housewife prepared breakfast and packed lunches in a blacked-out kitchen. If she had school-age children, they may have been in different schools, because after the military took over 28 schools, students were put on split shifts or transferred to bigger schools. If she had a preschooler, family or social organizations provided care. Then she would go off to work or volunteer work, saving her lunch to wait in line to buy groceries—whatever was available. Evenings were spent in the dark around the family radio, often draped with a sheet to hide the light from their tubes.

Her husband worked involuntary overtime. Absenteeism was a crime that was prosecuted in provost courts. In any spare time, he and his neighbors would dig trenches around schools and churches and build bomb shelters in each other's yards. He sometimes was called a "draft dodger" by servicemen, and at the same time, the military government defined his job as essential, keeping him from active-duty service.

Children played and worked. Labor laws lowered the working age to 12. With both parents working for the war effort, children had less supervision, but even they were called to support the war with volunteer work and mandatory service days in schools.

Of course, there were still family gatherings, but often, guests stayed overnight because travel was forbidden after curfew. Guests typically came by bus because gasoline was rationed.

Air-raid drills became less frequent after the victory at Midway, but the lingering threat of a land invasion caused "war jitters" throughout the war. The "invasion" by military and war workers pushed the Oahu population from 258,000 before the war to 348,000 in 1945. There were lines everywhere—bus lines, bank lines, gas lines, grocery lines—and that quiet upheaval showed up in daily life in simple frustrations yet honest gratitude that the military was there to protect them.

As evacuation drills expanded, more "realism" was included. The impact on residents and businesses in the areas of the drills was significant as seen here showing a simulated gas attack as people evacuate Chinatown along River Street.

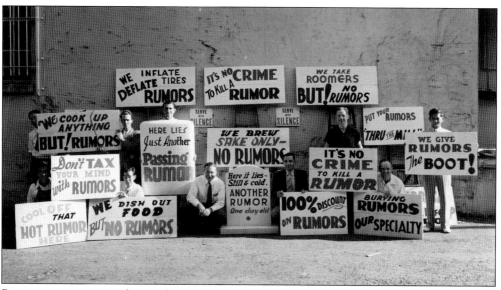
Rumors were rampant during the war, and efforts to stem them were constant. Rumors grew about newspaper advertisements as secret code, water contamination, and dogs barking in Morse code. The Hilo Junior Chamber of Commerce started this anti-rumor campaign of signs that was recognized in *Life* magazine in March 1942.

Perhaps the longest lines for rationing coupons were for gasoline. The city and county treasurer's office distributed coupons for 10 gallons of gas per month. (The 1940 Ford got 17 miles to the gallon.) The lines often wrapped for a half-mile from city hall to Thomas Square Park. To make waiting less painful, the Office of Civilian Defense sponsored musical groups to entertain the crowds.

On December 8, women queued up at grocery stores to purchase food. The Hawaii government assessed there was a 37-day supply of staple goods and a 73-day stockpile of flour but only a 13-day reserve of rice on Oahu. With shipping lanes restricted to vessels and known food shortage, widespread food hoarding prompted the implementation of a food-rationing coupon system.

63

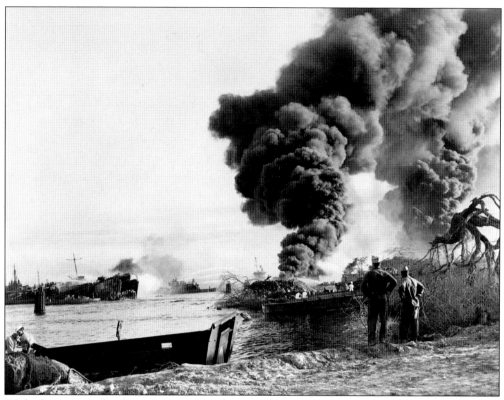

With the extent of military activity, accidents such as aircraft crashes, convoy accidents, and ordnance impact errors were not uncommon and posed hazards for the territory population. The most devastating accident occurred in May 1944 during preparation for the invasion of the Japanese-held Marianas. As a result of an explosion that occurred on a Landing Ship Tank (LST) moored in West Loch of Pearl Harbor, six LSTs were sunk, 163 personnel were killed, and 396 were injured.

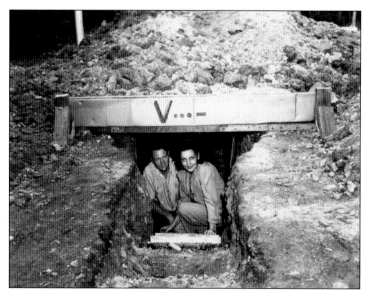

Mr. and Mrs. G.L. Gordon of Waikiki are pictured here in their homemade bomb shelter. A trench with a heavy cover piled deep with earth did the trick. Local contractors advertised digging a hole and sandbagging it over for $200 to $1,000. More elaborate shelters boasted plumbing and electricity. One wealthy Honolulu resident turned his pool into a shelter complete with rattan furniture, a radio, a hot plate, and a food pantry.

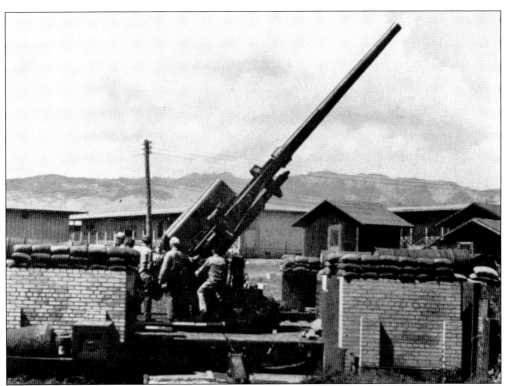

To maximize antiaircraft defenses on Oahu, guns were dispersed in numerous locations, often in civilian neighborhoods. This 120-mm antiaircraft gun was located less than 50 yards from Waipahu High School, seen in the rear.

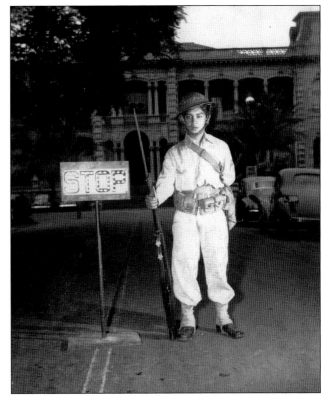

Security in and around previous civilian areas of Honolulu became a daily routine but no less cumbersome. Here, a territorial guard watches the entrance to the Office of Military Government in Iolani Palace, the historic home of Hawaii's kings and queens during the monarchy period.

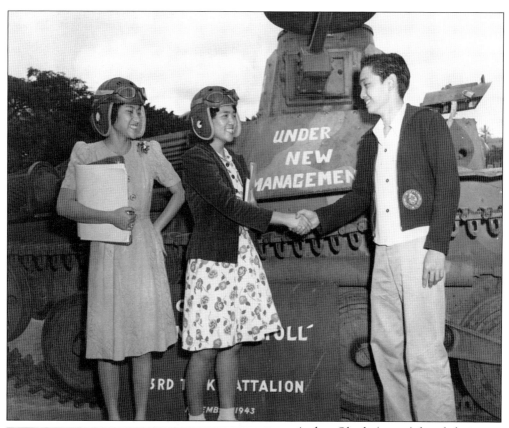

Audrey Okuda (center), bond chairman of McKinley High School, is being congratulated by Tadao Kobayishi (right), president of the McKinley High School student body. To the left is Jean Kawamura, bond chairman of Kaimuki High School. Together, these girls' schools raised $350,000 in war bonds to purchase a Liberator bomber that was named "Madam Pele." (The students are posed in front of a captured Japanese tank that was on display at McKinley High School.)

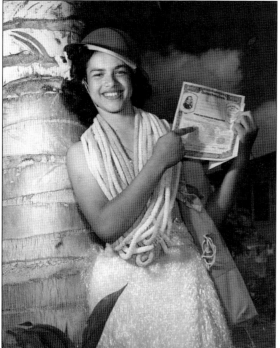

This "wartime hula girl" is actively promoting war bond sales. Hawaii consistently ranked among the nation's top per capita in bond sales. The average monthly sales in Hawaii was 147 percent of the quota, greater than any area in the country. Note the gas mask on her left shoulder.

Lei seller Lillian Kaahea of Chinatown defied the odds and kept her shop open. Here, she proudly shows off her war bond purchase. (Note the sign in the window advertising fish tripe for sale.)

Many Chinese dressed their children in traditional clothing to distinguish them from being Japanese. The Chinese were strong supporters of the war even though they lived under the Chinese Exclusion Act of 1882 prohibiting all immigration of Chinese laborers. In 1943, Congress repealed the act, although the quotas remained at a yearly limit of 105 Chinese immigrants. Here, a Chinese girl is selling war bond flowers.

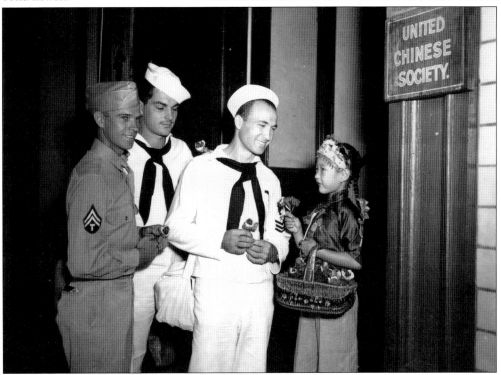

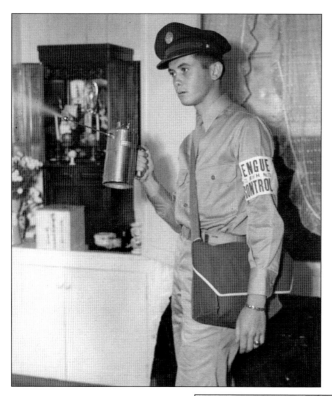

Over several months, personnel from the Board of Health, volunteers, and 300 servicemen conducted systematic visits to every residence, garden, factory, office, and open land site on the island at 10-day intervals, collaborating in a unified effort to tackle the dengue outbreak. Here, Private Gay of Waltonsburg, North Carolina, sprays a family living room. Additionally, the military declared all identified mosquito-infested areas as "Off Limits." Regrettably, from August 8 to September 13, 1943, Waikiki was among those restricted zones.

When servicemen returned from the Southwest Pacific with dengue fever in 1943, the Honolulu Chamber of Commerce appropriated $16,500 to help the Army fight the disease on Oahu. Dengue fever seldom caused permanent damage or fatalities, but it incapacitated its victims for two weeks. That serious impact on the labor force was feared, especially in 1943 when the war work offensive was at its peak. In areas where the disease could flourish, chemical warfare decontamination companies poured disinfectant over every possible breeding spot.

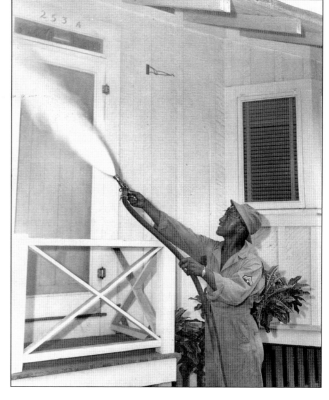

December 1941 was one of the wettest months on record, having six days of record rainfall that turned home bomb trenches into "fishing holes" and" play ponds" for children. Unfortunately, the stagnant water also was a perfect breeding ground for dengue-fever-carrying mosquitoes.

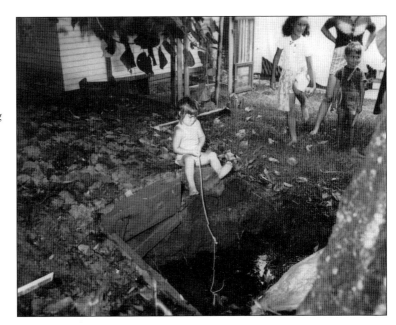

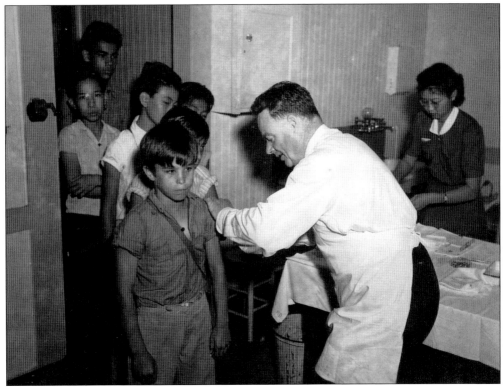

Immediately after the war was declared, the biggest compulsory vaccination program in the United States was undertaken. Vaccinating teams of military and civilian doctors, nurses, clerks, and Red Cross assistants immunized 200,000 persons at registration centers, and private physicians immunized 163,000 others. As a result, cases dropped from 56 cases in 1940 to 7 in 1944. Here, Richard Mareira gets his shot from Dr. Enright. (HSA.)

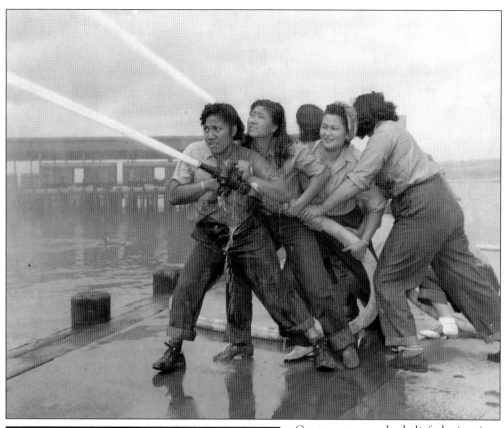

Contrary to popular belief, the iconic photograph is not of women firefighters on the day of the attack. Katherine Lowe and Elizabeth Moku were actually employed by the Dole Pineapple Cannery on December 7. Both, along with other cannery employees, applied for positions at the Pearl Harbor Naval Shipyard and were hired to work in the storage area handling volatile materials. As part of their duties, they operated fire hoses. The women captured in the photograph are, from left to right, Elizabeth Moku, Alice Cho, Katherine Lowe, and Hilda Van Gieson.

Bella Fernandez of Honolulu was the only rated boatbuilder in the Pearl Harbor Naval Shipyard. She was born on Kauai.

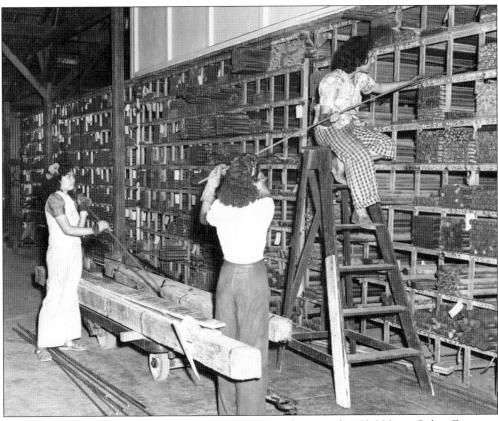

At its peak, Hawaii's workforce numbered 220,000 civilians, with 160,000 on Oahu. Fourteen hundred of these workers were women who took jobs traditionally held by men. In this photograph, women are working at the lumberyard of the Pearl Harbor Naval Shipyard. These higher-paying civilian defense jobs lured women from their comparatively lower-paying positions as waitresses, domestics, and laundry workers, causing a severe labor shortage in those professions. (NPSA.)

Because of the labor shortage of men, Raymond Tilford, manager of Globe Wireless, was forced to hire women as messengers. The newspaper reported the first messengers as "three attractive girl messengers in neat uniforms." From left to right are Elaine Morrison, Violette Ambrose, and Florinda Medeiros.

To fill the military's need for netting to camouflage equipment from enemy bombers, the Army contacted Agnes Makaiwi, president of the Hawaii Lei Sellers Association. Makaiwi negotiated fair salaries for her colleagues and persuaded the Army to hire "elderly women" who ordinarily might have been overlooked.

Hawaiian language scholar, author, hula expert, and cultural advocate Mary Pukui demonstrates the art of weaving camouflage nets to Primrose Kinolau, a lei maker, at a top-secret factory in Kalihi. The Army enlisted lei makers, fish net weavers, and artists to produce nets. Lei makers wove burlap strips, dyed in the colors carefully chosen by local artist Juanita Vitousek, into nets that had been woven by fishermen.

Isabel M. Gomes of Kaimuki works as a butcher in a downtown shop. The Office of Price Administration set meat prices at cents per pound—sirloin tip, 60¢; prime rib, 65¢; flank steak, 52¢; brisket, 35¢; and ground beef, 35¢.

The Honolulu Civilian Recreation Committee attempted to provide entertainment for civilians. The committee sponsored carnivals, shows, and public dances, mostly at the Aala Park and Beretania Streets playground. Throughout the war, two million people attended, and half of them were civilian war workers.

On Oahu, there was a "sweetheart deal" between the military and the Hawaii Sugar Planters' Association that they would not hire plantation workers directly. However, the pineapple and sugar companies contracted out the same workers to the military for construction work. The difference between the rate for field labor at 42¢ per hour and the 62¢ paid to the labor contractors was pocketed by the companies.

Lured by lucrative pay in civilian defense jobs, plantation workers left the fields, leaving crops unattended, which prompted the use of student labor. An order was signed permitting children 12 and older to be hired for full-time work. About 18,000 child labor certificates were issued each year during the war.

From June 1942 through June 1944, working three Sundays per month, the Kiawe Corps volunteers accumulated about 58,000 days of labor. Each Sunday, between several hundred and 1,000 men were transported by Army trucks to the coast to cut down kiawe brush so soldiers could see the coastline and fight off any invasion. The Army even transported a chaplain to provide services for the volunteers.

While men of the Kiawe Corps volunteers did the heavy labor of clearing the land, girls like Kiku Kaneshiro (left) and Mitsui Oshiro (right) were "waterboys," carrying drinking water to the men. Male students on Kauai were excused for up to six months of school to string barbed wire around the island.

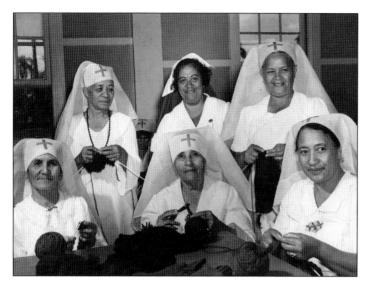

These Red Cross volunteers of Kaumakapili Church who knitted socks, sweaters, and beanies for World War I doughboys were called into service again. From left to right are (seated) Julia Smythe, Lily Kamiopili, and Maggie Apoi; (standing) Helen Kapaona, Elizabeth Kamahoahoa, and Annie Kopa.

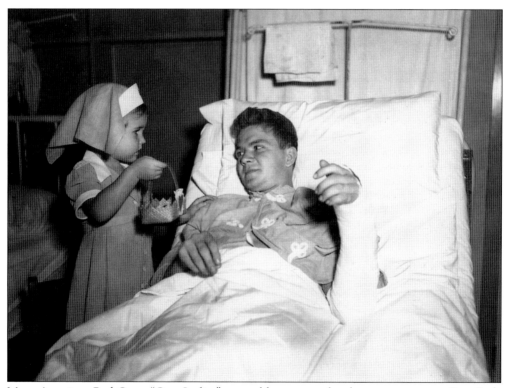

Many American Red Cross "Gray Ladies" were older women, but here, a very young Gray Lady delivers an Easter basket to a patient. Between March 1942 and August 1945, the 241 volunteers gave 32,998 hours of service. Navy wives who had been trained on the mainland were the first Gray Ladies. But within six months of the attack, 450 women were trained on five islands.

Japanese women were at the forefront of volunteering for the American Red Cross. Japanese-born women—the older ones abandoning their kimono for western dress—sewed, knitted, cooked, and built bunny masks. Japanese women also comprised the majority of students in the "Speak America" program, teaching English and American customs to aliens. Japanese language schools, shrines, and temples were shut down. Funds of Japanese banks were liquidated, and still, the Japanese in Hawaii gave full support to the war effort.

Ships normally carrying goods and foods to Hawaii were commandeered by the military to carry war supplies. Not only were car tires and gasoline in short supply, but small and large appliances were scarce. Here, housewives organized a small appliance swap. Appliances were so scarce that a man bought $80,000 worth of bonds to be guaranteed getting the first postwar refrigerator.

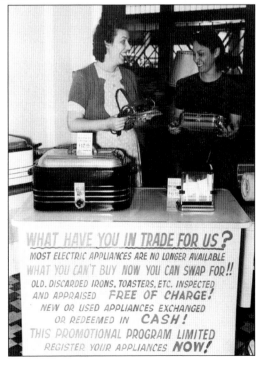

77

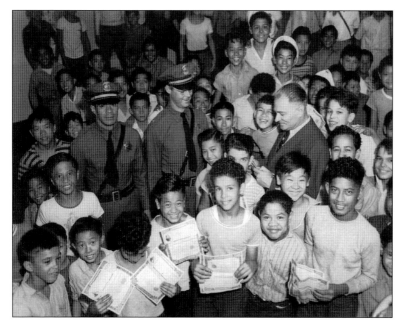

On any given day, there were more than 1,000 boys on the streets selling shoeshines for 25¢, and much of their business was from sailors standing in brothel lines. But the boys also sold war bonds. Here, police chief W.A. Gabrielson is awarding a wristwatch worth $60 to the shoeshine boy who sold the most war bonds.

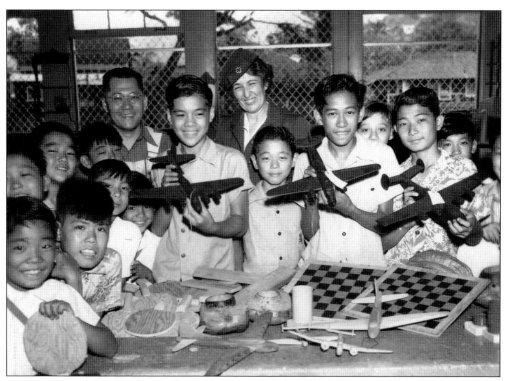

Boys at Central Intermediate School showcase model airplanes crafted for servicemen. These airplanes were meticulously painted to resemble authentic enemy planes, serving as a tool for learning plane identification.

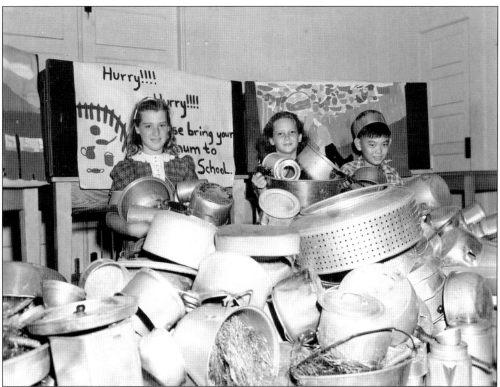

Hundreds of tons of scrap were collected at schools and churches, and wardens moved it to the War Materials yard. Much of the salvage material was handled by Industrial Reclaimers, a company formed in 1942 to dispose of scrap. The company obtained contracts with the Army and Navy to salvage the materials and ship them to the mainland for reuse.

During the first five months of the war, Hawaii citizens collected 1,464 tons of rubber, and Army transports carried it to the mainland for reuse. Here, Boy Scouts roll tires from a gas station on Beretania and Keeaunioku Streets to a rubber collection station. Rubber was at such a premium that Oahu Prison inmates were used to work at an abandoned rubber plantation on Oahu. It took two years and a significant cost to produce 25 tons and was considered not worth the effort.

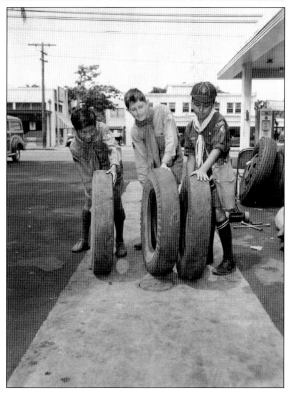

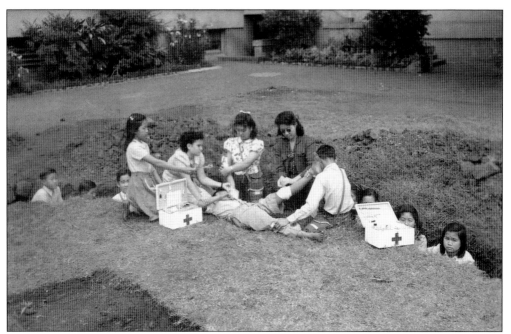

School curriculum taught children how to take care of gas masks, salvage supplies, and how to behave in bomb shelters. Here, students of Liluokalani School receive first aid training while in the dugout trenches. Among the identified are Abigail Ching, Eva Castro, Lila Lee, Richard Choy, instructor Edith Chang, and Johnson Wong as the wounded victim.

Parents, teachers, and students dug many of the trenches at schools on Oahu. This zigzag pattern was designed so that a single bomb would not injure more than 50 people. Drills were conducted to ensure that the students could get to the trench shelters in a timely fashion if the air-raid warnings were sounded.

A "Trench Safeguard Boy" times his fellow students in an air-raid drill. It took 2 minutes and 45 seconds for over 2,000 McKinley High School students to evacuate their buildings and huddle into trenches.

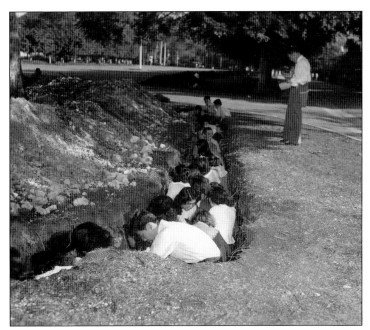

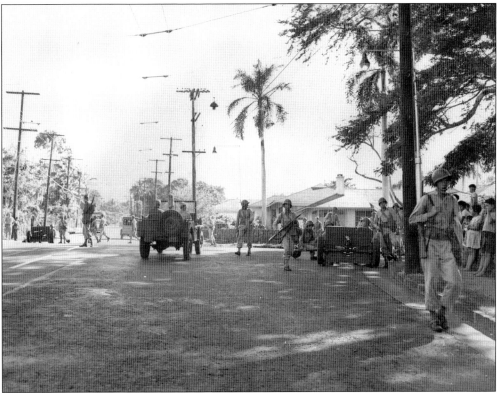

This photograph shows an Army anti-tank unit conducting their ambush training in a civilian neighborhood, no doubt to the delight of the youngsters lined up along the wall watching. This style of training was designed to protect the islands and was not geared for the upcoming Pacific islands campaigns.

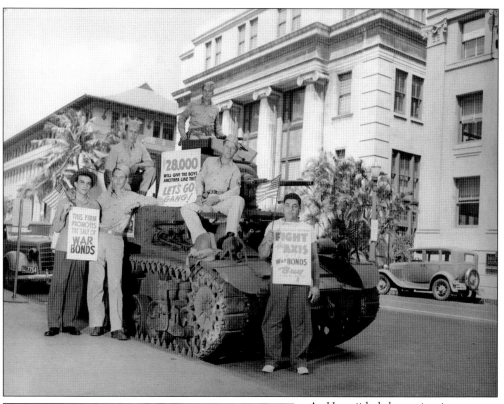

As Hawaii led the nation in war bond sales, the methods to sell became unique and eye-catching. As there was suspicion of those not in the military, companies that had essential workers not eligible for the draft often would sponsor bond drives to help relieve the suspicion. Note the sign by one of the men that says, "We can't all be there."

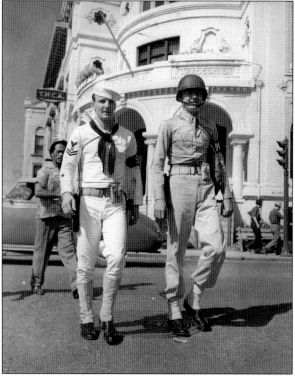

With the large number of servicemen stationed on Oahu, Navy Shore Patrol and Army Military Police were a common sight 24 hours a day. With the imposition of martial law, their powers were expanded to include some civilian offenses. This relaxed patrol is outside the downtown YMCA, likely when many of the military personnel were deployed, perhaps in early 1944.

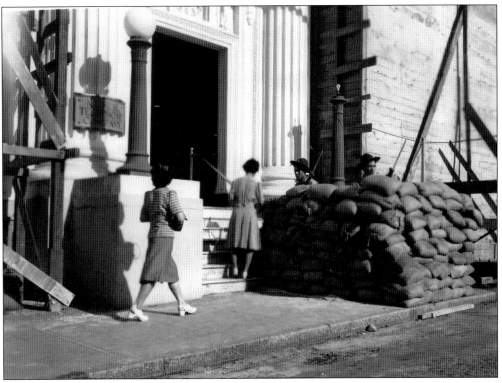

The Hawaii Territorial Guard, made up of mostly Japanese Americans, was a paramilitary unit mobilized on December 7, 1941, with the Reserve Officer Training Corps unit at the University of Hawaii as its core. These paid ROTC-trained men, under the control of the territorial government, were immediately armed and assumed guard duties at key infrastructure points. Here, two Guardsmen are posted in a makeshift bunker at the Mutual Telephone Company in downtown Honolulu.

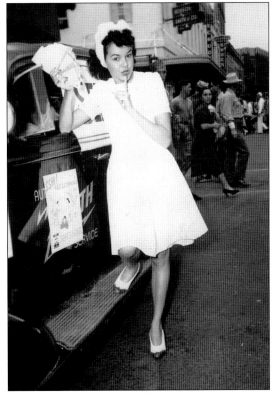

Rumors often ran rampant in Hawaii throughout the war. With so many people related to each other, many volunteers, defense workers, shipyard workers, National Guardsmen, and others often wanted to share the latest gossip. Efforts remained concerted to squelch rumor. This Honolulu Junior Chamber of Commerce young lady is doing her part.

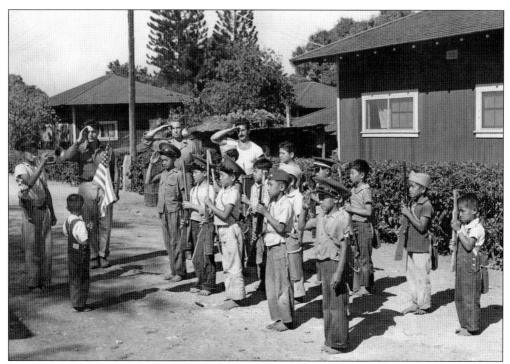

The lives of children in the plantation villages were disrupted as the military took over. Recognizing this, the Army adopted a program of working with school-aged children regularly. Here, one of "the Barefoot Battalion" forms up under the leadership of their commander as their bugler sounds "colors."

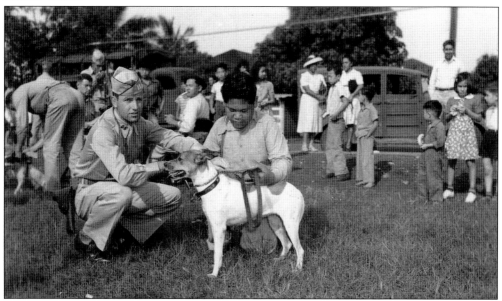

In May 1942, islanders were urged to loan their dogs for war service if the dog was not required for the safety of individuals or a family. Over 3,000 dogs were volunteered, and of these, 900 were accepted. Some served with sentries in Hawaii, others became scout dogs on battlefields from Okinawa to Guadalcanal.

On December 7, all schools were closed. On Oahu, most schools reopened on February 2, 1942, to a limited schedule. A total of 28 public schools and 3 private schools were taken over by the government, forcing students into split schedules. Many students worked part-time or developed lucrative businesses on their own. Pictured are girls who charged 25¢ for shoeshines and made as much money as their parents' wartime wages.

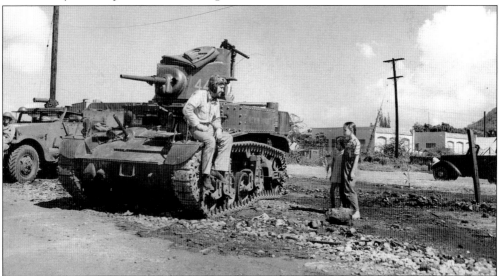

After the attack, schools were closed for six weeks, and mothers were urged to volunteer or work in war service. When schools reopened, they lost 25 percent of the teaching staff; some evacuated to the mainland, while others took war jobs. The schools themselves were centers for the distribution of gas masks, liquor permits, salvage centers, and military practice fields. Here, children chat with a tanker at McKinley High School.

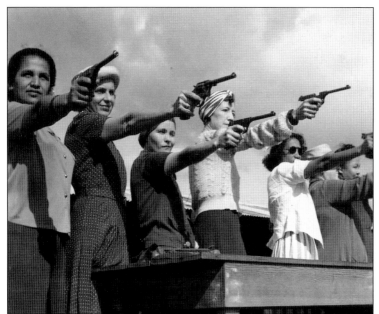

During the weeks after the attack, all citizens were encouraged to learn self-defense. Here, women at the Honolulu Police Department pistol range are being trained. However, Japanese aliens and Japanese Americans had all their weapons confiscated, along with any transmitting radios, cameras, and anything considered a signaling device.

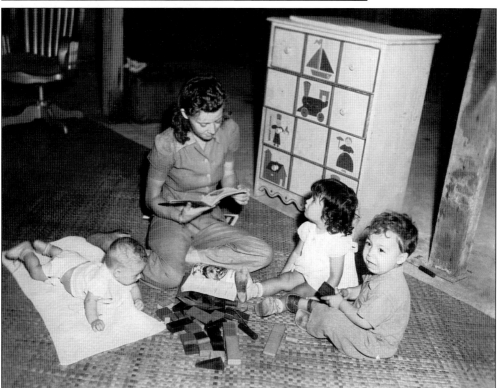

During the war, over half of Honolulu's women joined the workforce, with many also dedicating their time to volunteer positions. Despite these efforts, there remained a significant shortage of workers, especially among women with young children who lacked suitable childcare. In response to this challenge, some companies established their own day care centers. Here, Eloise Zonfrilli is reading to the children at the Overall Cleaning and Supplies Company.

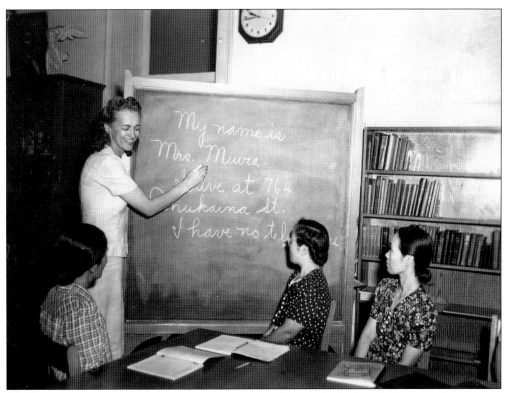

In October 1942, the Emergency Service Committee launched the "Speak American" campaign. Business signs in Japanese were taken down, and many businesses required only English to be spoken at work. Most students were Japanese women. The classes taught language and American culture.

Under martial law, individuals who were permitted to possess cameras, including professional photographers, were granted the privilege of having one roll of film. After the development of that roll, it underwent scrutiny by a censor. When the customer picked up his photographs, he was then permitted to purchase additional film. Here, two sailors pose for a professional portrait.

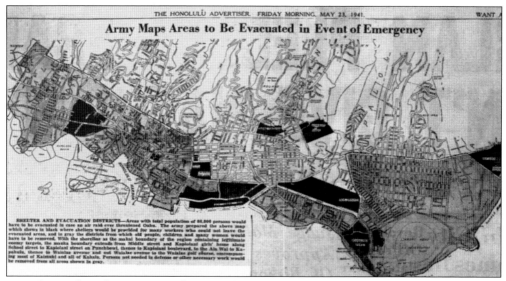

According to the military governor, "Areas with a total of 86,000 persons would have to be evacuated if an air raid ever threatened Oahu." The Army prepared this map with the areas in black marking shelters for workers who could not leave the area, and the gray showing areas "from which old people, children, and many women would be removed. Persons not needed in defense or other necessary work would be removed from all areas shown in gray."

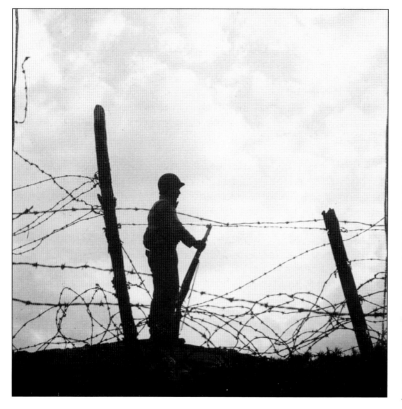

Sentries remained on Hawaii's beaches until late into the war. Here, Pfc. Angelo Reinai of Utica, New York, patrols one of Oahu's beaches. This image was captured by Joe Rosenthal, the same photographer who shot the iconic picture of the Marines raising the flag on Mount Suribachi at Iwo Jima. (NA.)

Six

OFF DUTY

Honolulu before the war was still a small town of neighborhoods with unpaved streets. It was a community where everyone knew everyone and most were related. In 1940, when the "first invasion" of civilian defense workers occurred, Hawaii's population was less than 15 percent Caucasian, and African Americans, other than military or government workers, were virtually unseen.

These newcomers expected to see the Hollywood Hawaii with a hula girl under every palm tree. What they got was a strong family-centered community where "hula girls" had big burly brothers to protect them from mainland men. The US Army's *Pocket Guide to Honolulu* warned, "You'll find that telephone numbers here carry the same classification as war plan. A man in uniform is about as novel here as a light bulb in a sign on Times Square. There simply aren't enough wahines to go around."

Oahu was called "the Rock." It was a small island of 600 square miles where entertainment was either at the base, USO, church groups, or Hotel Street (brothels). Hawaii was a strange place. It might have been the first time they ate Asian food or danced with a non-Caucasian woman. Enlisted men danced at the Army's Maluhia Club, while officers relaxed in the estates of the social elite, like Doris Duke's Shangri la.

But for officers and enlisted, Hawaii was a limbo—not home and not the battlefront. It was a time to wait to go to war. After the war, many men stayed in the islands. They married local women and raised families, adding to the cultural complexity of Hawaii. And many more returned to the islands with their families to show them what life was like for them.

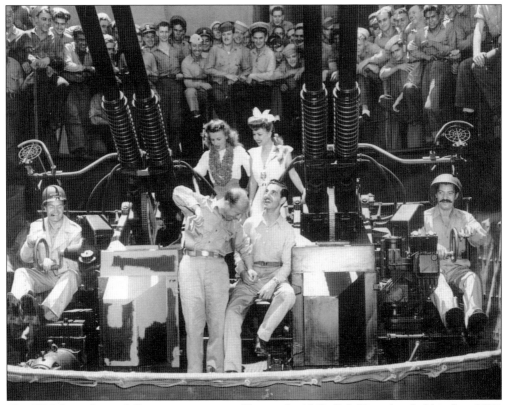

The USO brought top-billing entertainers to Hawaii. In 1942, Bob Hope headed his first USO tour outside of the continental US. Identified are Bob Hope on the left, wearing a helmet; Frances Langford, wearing a lei; Tony Romano, seated in the middle; and Jerry Colonna, seated on the right. (NPSA.)

A singing group of Marines called the Invaders often performed for servicemen. Their leader, Pfc. Tommy Gleason, second from the left, had a professional group for 13 years that performed in the Ziegfeld Follies before joining the Marines. They were often joined by 1st Lt. Bob Crosby, Bing Crosby's brother, pictured on the right.

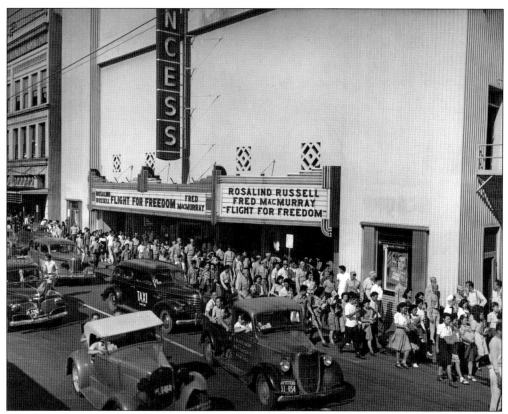

Matinees were a way of life because, under curfew orders, all restaurants and businesses had to close by 4:00 p.m. to enable their workers to get home by the 6:00 p.m. curfew mandating all civilians off the street. Patriotic movies were popular in 1941. Top box office hits included *A Yank in the RAF*, *Sergeant York*, and *Caught in the Draft*.

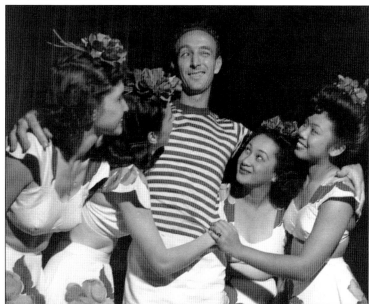

Shows were put on for the civilian war workers. Here is a scene from *Waikiki Diary*, put on at the Pearl Harbor Naval Shipyard. The man in the center is Kaskell Weaver, a civilian employee. The women are, from left to right, Helen O'Brien, Anne Sharlip, Ellen Winghong, and Felica Seneris.

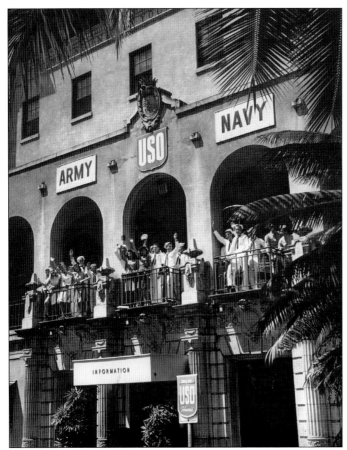

The USO in Hawaii rose from a handful of clubs in 1940 to dozens of clubs throughout the territory. In 1942, the USO had 80 staff members, 3,000 volunteers, and 400 USO Camp Show entertainers operating 51 clubs and 18 mobile USO vehicles across five of the Hawaiian islands.

While more than 50 USO clubs were opened to accommodate the troops throughout the territory, one of the most memorable was the Crossroads USO in Makawao, Maui. Ethel Baldwin leased a vacant store and, with her volunteers, created a western-themed respite with reading rooms, Ping-Pong, and pool tables that provided a comfortable place to gather for the nearly 200,000 servicemen who lived and trained there.

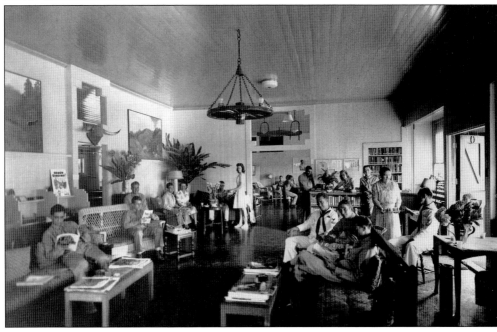

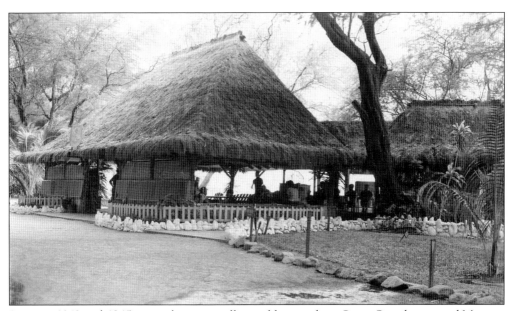

Between 1942 and 1945, more than one million soldiers, sailors, Coast Guardsmen, and Marines transited through Hawaii en route to the Pacific war. Often months of training across the islands preceded combat, and military men embraced liberty options during their frequent and sometimes lengthy stays. Here is the Campbell USO located in southwest Oahu.

In May 1945, Hui Welina was opened as the first USO club for enlisted women in the Pacific. It was staffed by USO employees and volunteers from 15 area sororities, including Kappa Kappa Gamma. Located in the home of Princess Kawananakoa, "It was a busy spot with girls in and out all day using the checking services, gathering information, using kitchen facilities to make a made dinner for friends."

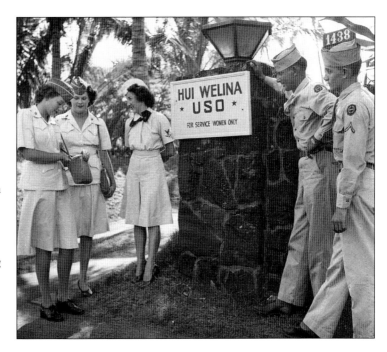

This sailor is posed in an outrigger canoe in front of the Royal Hawaiian Hotel. The Navy erected a baseball diamond on the front lawn and turned the beauty parlor into a dispensary. Before turning the hotel over to the Navy, the hotel management cemented over the opening to its well-stocked wine cellar to make it look like part of a walkway, keeping it secret for the duration of the war.

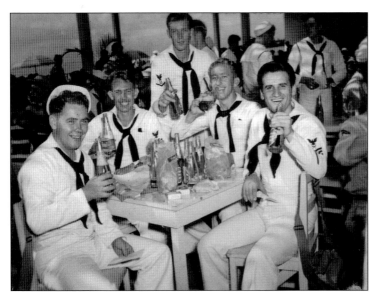

These sailors are enjoying a Christmas beer at the Breakers Club on the beach at Waikiki. The club was operated by the Navy but welcomed all services. It stood approximately where the Waikiki Aquarium is now.

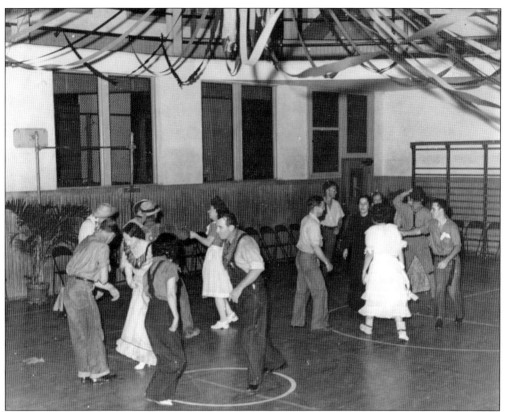

The USO War Workers' Club was established in 1943 at the Central YMCA, Honolulu. An average of 5,000 men a month visited. On Halloween 1943, the club sponsored a square dance party. Besides the YMCA, St. Clement's parish hall held weekly dances, and the Church of the Epiphany held dances at Liholiho School in Kaimuki, as did the Nuuanu YMCA.

Early in the war, there had been discussions regarding taking down the statue of Kamehameha I to protect it from damage. The Hawaiian community was adamant that the statue of this warrior should remain standing. Perhaps owing to his strength as a warrior, it went undamaged throughout the war.

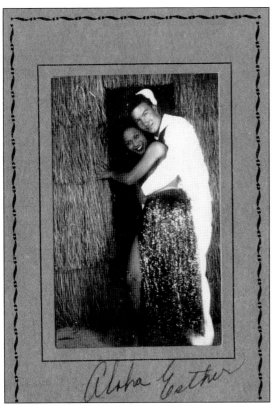

The pricing policy established by the Office of Price Administration stipulated that a photograph featuring one girl cost 25¢ and with two girls, 75¢. Margaret Trease was an unsung hero of the war. She undertook the noble task of collecting unclaimed photographs adorned with hula girls and, with Red Cross assistance, compared them to the names of deceased servicemen. When she found a match, she mailed the last photograph of their sons to the grieving families.

During the summer of 1942, over 80 Hotel Street prostitutes went on a 21-day strike against the restrictions imposed on them by the Honolulu police. General Green took up their cause and ruled the restrictions of the police were extreme and unjust. Hotel Street served 100 men per day at $3 for three minutes. Here, GIs wait in line to "climb the steps." (Brothels were typically on the second floor.)

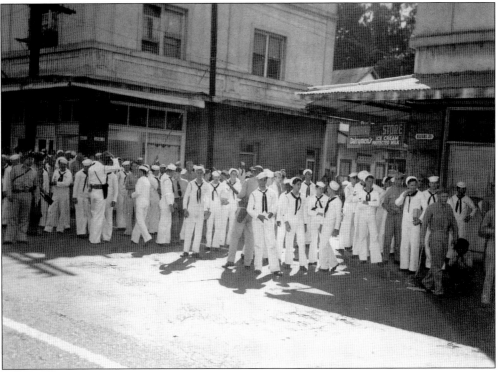

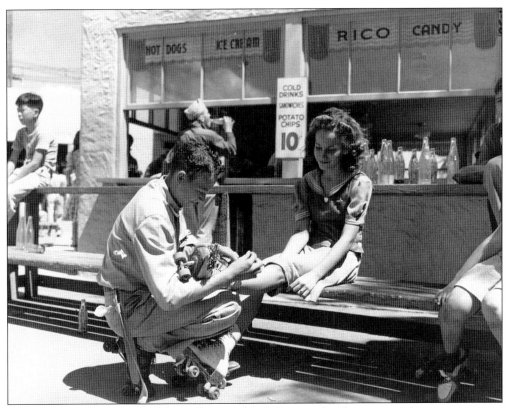

The women of Hawaii found themselves caught in the complex dynamics of dating servicemen, torn between the perception of it as a "patriotic duty" and the potential shame of being labeled "fast." To strike a balance, numerous women opted for involvement in USO activities or other well-regulated events, such as roller-skating parties organized by social and church groups.

The "Miss Fixit," who wrote a column in the *Star-Bulletin*, arranged for lost wallets to be returned to their owners. (Monday morning beach cleanup crews found many wallets.) And if a GI's mom asked her to arrange a birthday cake for her son, Miss Fixit came through. Miss Fixit's real name was Alicia Adams. Here, sailors enjoy Waikiki in front of the Moana Hotel.

Ruth Luis at Detor Jewelers sells war stamps to sailors during "Uncle Sam's Quarter Hour" of Retailers for Victory Week, when 1,500 businesses halted their sales and only sold war bonds from 11:45 a.m. to noon on July 1, 1942.

Automobile manufacturing was stopped in 1942, and in Hawaii, where costs were inflated and a scarce inventory was available, very few average servicemen could afford cars. The Navy and the Territorial Highway erected plywood signs, like this one on Pearl Harbor Road between the base and Waikiki.

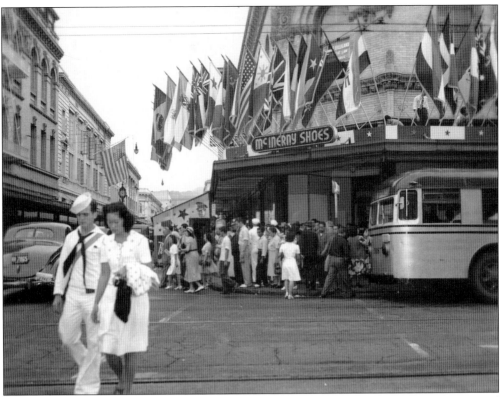

Despite military efforts to discourage interracial marriages by requiring servicemen to obtain official permission before marrying, from 1943 to 1954, about 40 percent of all Caucasian bridegrooms married non-Caucasian women. Half of these married part-Hawaiian women, and a fifth married Japanese. Although such interracial marriages were known before the war, they were less common.

Numerous groups and organizations provided entertainment, relaxation, food, hospitality, and a touch of home to the servicemen. The major contributor to this effort was the Salvation Army. Here, a Salvation Army officer and three workers provide coffee and donuts to soldiers taking a break from maneuvers in an Oahu neighborhood.

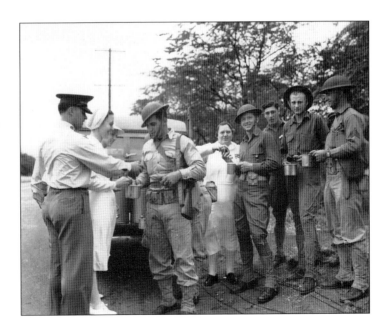

Lieutenants Wilma Kaemlein from Monroe, Michigan, and Agness C. Malone from Massillon, Ohio, Army nurses, assist Kuulei Kehakaloa ice skating for the first time. Owing to the critical shortage of nurses on Oahu, numerous Army nurses were temporarily assigned to local civilian hospitals.

Shown is part of the crowd of 25,000 on hand at Nimitz Arena to witness the Pacific Area boxing championship between the Army and Navy on April 19, 1945. Inter-service boxing matches were major morale events throughout the war. This event decided the bragging rights for the year. Navy triumphed.

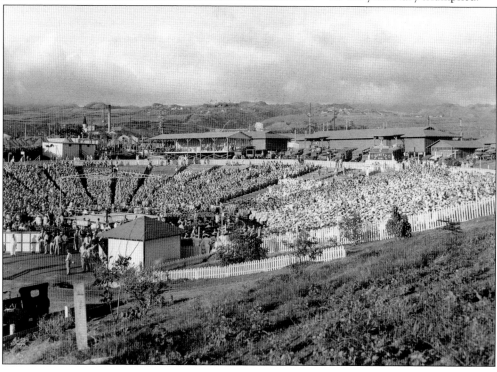

100

Ethel Baldwin's letter highlights the commitment of volunteers across the Hawaiian Islands in welcoming service members during holidays. During the war, the Baldwins offered the historic Fred C. Baldwin Memorial Home to be used as a military hospital. The elderly residents of the Memorial Home were moved to the Pioneer Inn in Lahaina. (HHS.)

U.S.O.
SOMEWHERE IN HAWAII

Dec. 10th, 1943

Dear USO Hostess:-

We will need your help at the Crossroads USO either on Christmas eve or on the afternoon of Christmas day.

We are planning a tree on Friday at 5:30 sharp, when we will have a good short program, and the arrival of Santa Claus, followed by the distribution of small gifts and cookie bags, and the serving of a fruit drink. This is where your services will come in! (Husbands and small children will be welcome.)

Then on Christmas day we need Hosteses in the afternoon to help make the boys feel at home, and with any informal singing or games we decide to have.

Please drop me a line soon and let me know if it will be convenient for you to assist, and on which day.

Sincerely,
Ethel F. Baldwin
Chairman Crossroads USO Club Com.

Stephen McMurray, seated on the ground in the middle of the photograph looking toward the camera during a Camp Maui Art Class, was a combat artist during the invasion of Japan. He served at Iwo Jima and sketched the battle. (WWM.)

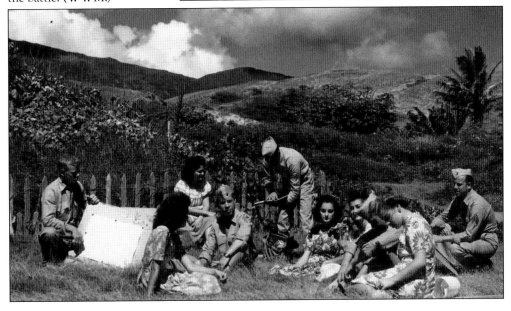

101

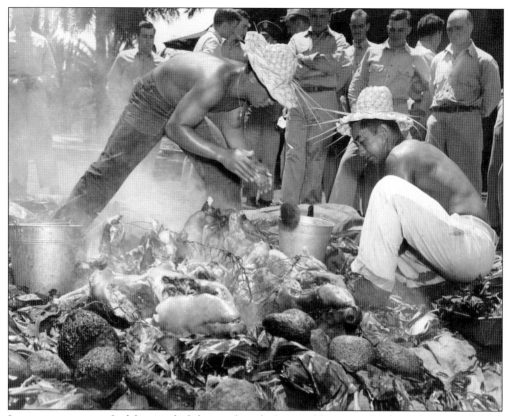

Luau was a means of celebrating holidays and made for notable events for the military. Authentic ones required local folks to dig and maintain an imu (pit) to roast the pig using hot rocks and steam. In this photograph, GIs watch local Hawaiians prepare the pig.

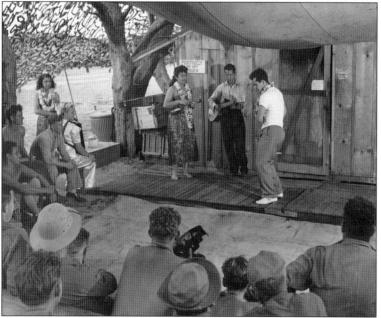

Luau usually included some form of local entertainment, or *kanikapila*. At this luau sponsored by the neighbors for "their" military men camped at Kahuku, some of the residents perform a spontaneous hula and music interlude.

Victory Mail (V-mail), instituted in June 1942, adopted a system to streamline mail delivery for servicemen. This process involved reducing the volume and weight of mail by capturing it on film. V-mail letters were opened, censored, and microfilmed. Special holiday V-mail stationery, like the "Mele Kalikimaka" (Merry Christmas) presented here, added a festive touch to correspondence during celebratory occasions.

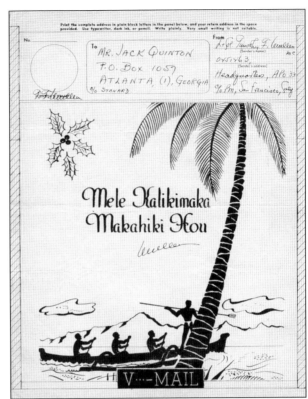

May 1, May Day, is Lei Day in Hawaii, when everyone wears and gives lei. It is celebrated with parades, hula performances, lei contests, and the May Day Royal Court representing the Hawaiian royalty. Lei Day Royal Court ceremonies were suspended until May 1945. Here, sailors help the queen to her throne.

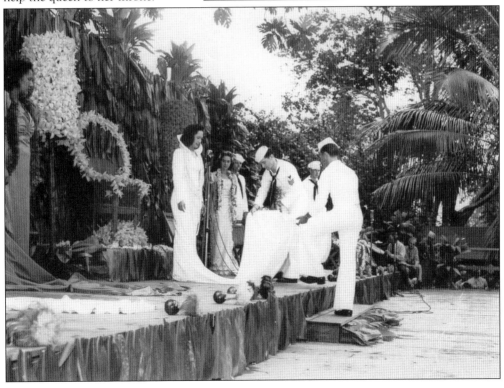

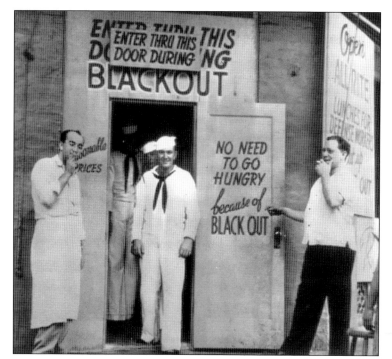

The Times Square Grill on Hotel Street had an indoor service that was open 24 hours for shift and night workers. There was a special blackout entrance, and it was air-conditioned. (MKS.)

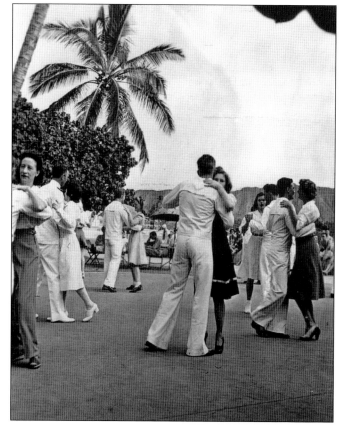

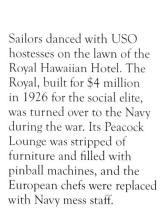

Sailors danced with USO hostesses on the lawn of the Royal Hawaiian Hotel. The Royal, built for $4 million in 1926 for the social elite, was turned over to the Navy during the war. Its Peacock Lounge was stripped of furniture and filled with pinball machines, and the European chefs were replaced with Navy mess staff.

Seven

Americans of Japanese Ancestry

In 1941, approximately 150,000 Japanese and Japanese Americans were living in Hawaii. Forty thousand were aliens, most of whom could not read or speak English. Sabotage was a credible fear among the military and non-Japanese residents. But interning the Japanese would have been a business disaster—the economy could not withstand such a loss of labor, nor could it support a vast internment camp.

The Japanese in Hawaii were forced to become "super patriotic" to prove they were no threat. To do that, they gave up their language, culture, dress, and even their religious worship. Japanese language schools, shrines, and temples were shut down. Funds of Japanese banks were liquidated, and still, the Japanese in Hawaii gave full support to the war effort.

When the Nisei (American-born Japanese) were permitted to join the military, 40 percent of eligible men flocked to registration centers. Most served in the 442nd regiment. It is believed that their rescue of the Texas Lost Battalion in 1944 was a factor in Lyndon Johnson's support of Hawaii becoming a state.

Older Japanese women abandoned wearing kimono for Western dress. They were at the forefront of volunteering for the American Red Cross; the younger ones volunteered in war service. Japanese women comprised the majority of students in the "Speak America" program teaching English and American customs to aliens.

After the war, the Nisei veterans took advantage of the educational benefits of the GI Bill, and within 10 years, they rose to leadership roles in government, business, and education. In 1940, Japanese were 2.9 percent of appointed officials, and in 1950, they were 10 percent. In 1940, they were 14 percent of elected officials, and in 1950, they were 26 percent. Then there was the "Revolution of 1954" that saw the rise of the Democratic party in Hawaii led by the Nisei veterans. They shaped a state that fostered social mobilization, ethnic equality, and a successful middle-class emergence.

The spirit of the "Go For Broke" continues to inspire a mythical respect. They strived "For the sake of the children" (*Kodomo no tame ni*), and the present generations thank them with *okage sama de* (What I am today is because of you).

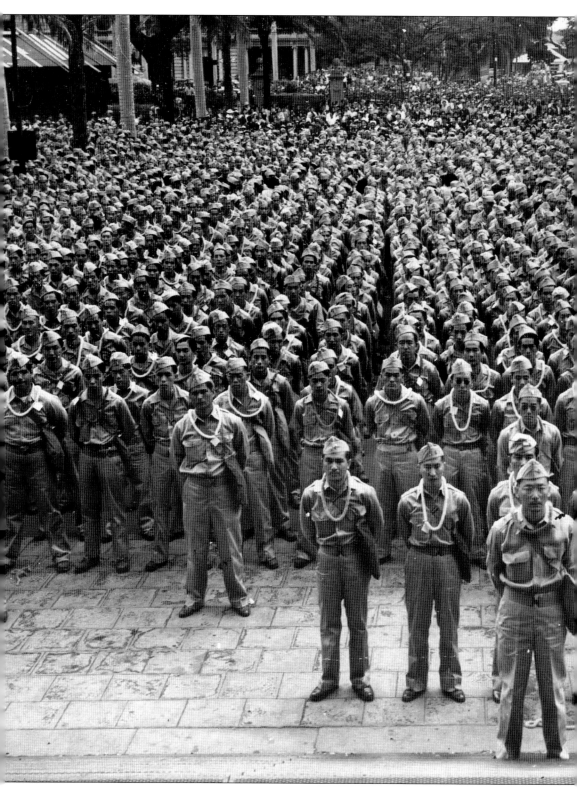

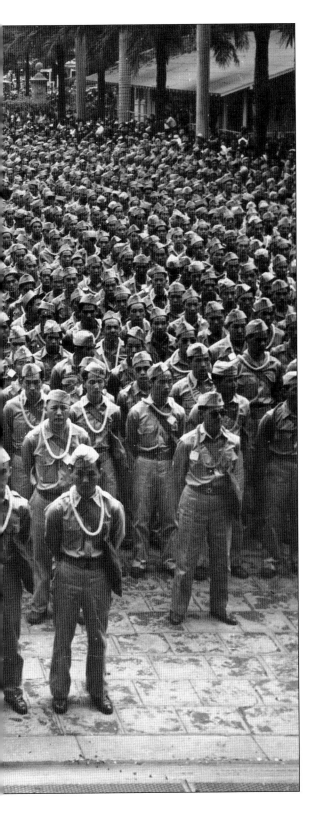

In February 1943, President Roosevelt activated the 442nd Regimental Combat Team. Hawaiian-born Nisei (second-generation Japanese Americans) made up roughly two-thirds of the regiment, with the remaining third composed of Nisei from the mainland United States. This was the scene on March 28, 1943, with downtown jammed with 15,000 spectators to see them off. (HSA.)

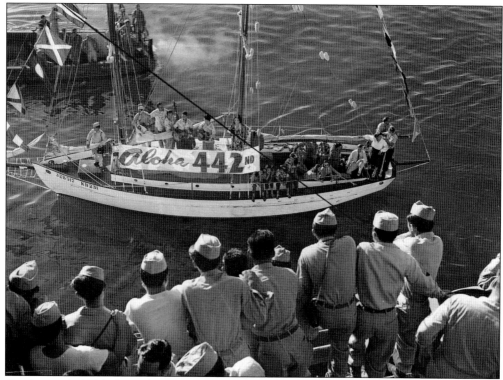

On August 9, 1946, the yacht *Lady Joe* welcomes home the 442nd aboard the *Waterbury Victory* transport ship in grand "local style" with musicians and a hula troupe. The 442nd was deactivated at Kapiolani Park after the Veterans Day Parade.

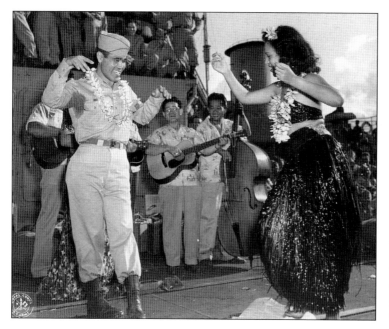

Entering Honolulu harbor, Hawaiian hula dancers and musicians boarded the transport *Waterbury Victory* off Diamond Head and entertained the troops of the 442nd Combat Team upon their return home. Here, Lt. Unikei Uchima of Kauai, a member of the 442nd, is seen doing the hula with Leonetta Osorio.

108

Most soldiers of the 100th Battalion trained at Camp Shelby, Mississippi, and they brought their Hawaiian culture and the spirit of aloha with them. The Camp Shelby Hawaiian Serenaders band are, from left to right, (seated) Pvt. Jiro Watanabe (standing) Pfc. Robert Otani, S.Sgt. Ken Okamoto, sponsor Earl Finch, Cpl. Frank Suzuki, Pvt. Robert Tarauchi, and S.Sgt. Robert Shimabuku.

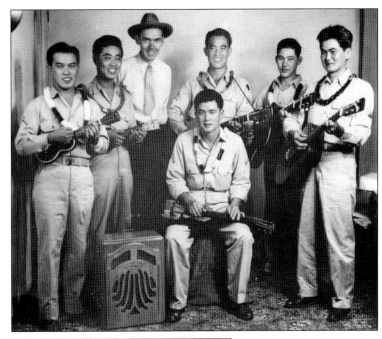

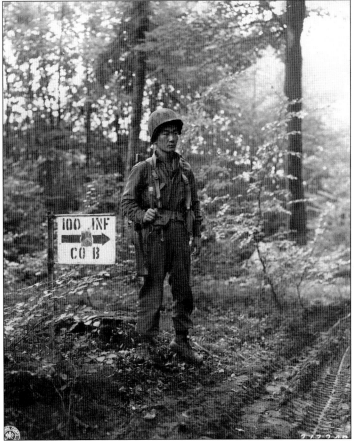

The 100th Battalion's high casualty rate at Anzio and Monte Cassino earned it the unofficial nickname of "Purple Heart Battalion." The 100th/442nd Regimental Combat Team still is the most decorated unit for its size and length of service in the history of American warfare. The 4,000 men who were sent to the European theater in April 1943 had to be replaced nearly 2.5 times. In total, 10,000 men served.

The *Honolulu Star-Bulletin* caption of this photograph reads, "Sergeant Shigeki Fukuda, of Kaneohe, of the 442nd Regimental Combat Team and his girl stop for a brief look at his discharge papers." Fukuda's girl was Edna Oda, who became Mrs. Shigeki Fukuda.

Iuemon Kiyama tearfully embraces his son Sgt. Howard Kiyama. The 442nd endured a staggering 9,486 total casualties. Howard Kiyama, who passed away in 1994, rests in peace alongside his fellow 442nd members in a designated section of the National Memorial Cemetery of the Pacific. (Robert Ebert received a Pulitzer Prize for this image.)

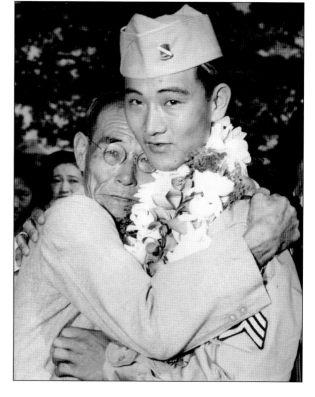

110

Eight

A NEW ERA

Following V-J Day, barbed wire, gas alarms, gun turrets, and rationing disappeared abruptly. However, even three and a half years postwar, temporary structures still dotted the grounds of Iolani Palace, and unused temporary war housing persisted. Although tangible remnants endured, it was the societal transformations that reshaped Hawaii dramatically. Racial, cultural, and economic barriers were dismantled, giving rise to a burgeoning middle class.

The AJA GIs seized the educational opportunities offered by the GI bill, reshaping the power dynamics of Hawaii. Emerging as leaders in politics, business, and education, they initiated the development of planned communities inspired by the old plantation village model. These were modern neighborhoods that included stores, entertainment, and professional services as well as religious and social activities. Olokele on Kauai was one of the first planned communities.

While some women kept their wartime jobs, most went back to being housewives. The postwar era witnessed a rise in divorce rates and an increase in births out of wedlock. It also experienced a surge in unions, transforming Hawaii from one of the least organized regions to one of the most unionized. Reasons given for that include the frustrations of years of martial law that set salaries, criminalization of absenteeism, the restricted ability to change jobs, and the exposure to mainland workers who talked about the advantages of unionization.

Despite aspirations for statehood, Hawaii faced a prolonged wait, finally achieving it a decade later. But the territory was intent on becoming recognized. It vied to have the United Nations center built in Waimanalo. Hawaii argued, "The Territory of Hawaii is remote from any national capital and therefore removed from concentrations of political and economic pressure: it has an equable climate and natural scenic beauty . . . by reason of the diversified racial origins of its population, and its record of success in achieving racial harmony, it provides a uniquely appropriate environment for an organization dedicated to world amity."

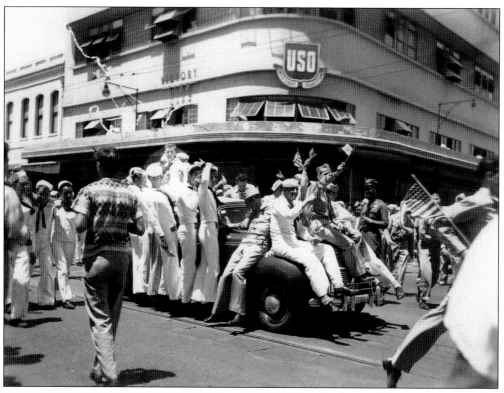

On August 15, when the surrender was announced, a spontaneous celebration broke out downtown. These sailors, joined by a couple of Marines, definitely convey a sense of relief and excitement as they "appropriate" this car in downtown Honolulu. Military officials had estimated the American casualty rate would exceed 500,000 had the invasion of Japan been necessary.

Church bells rang, air-raid sirens wailed, gas alarms pealed, and jalopies, jeeps, and carts loaded to the running boards joined the celebration. Paper confetti of torn wartime forms fell from the windows. Fireworks (which were illegal) went off, and people wept, sang, and cheered in the streets. The war was over.

These jubilant Marines borrow the submarine service idiom of "clean sweep" where subs would display a broom from their mast upon returning to port having sunk every ship they engaged. Here, they are certainly celebrating the clean sweep of the Pacific campaign.

Minutes after the radio report the night of August 13 that the Japanese had agreed to the Allies' surrender terms, this scene of Pearl Harbor was photographed from Admiral of the Fleet C.W. Nimitz's rear headquarters. At the time, Nimitz's forward headquarters was in Guam. The blaze of light and the streamers just right of the center of the picture are around the fleet landing. To the left is Ford Island. Solid white lines in the foreground are from automobile headlights on highways.

113

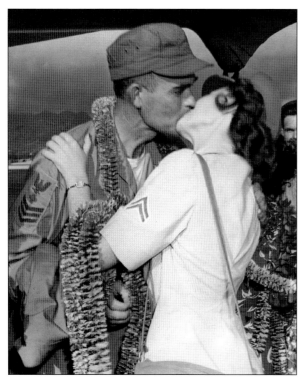

Pharmacist Mate First Class John Castleton arrives at Naval Air Station Honolulu along with 18 other Navy and Marine Corps Recovered Allied Military Personnel (RAMPs). Since he was attached to the Marines as a corpsman when captured, he wears a Marine Corps uniform. His welcome kiss is compliments of Marine corporal Alice Philpott.

Ens. George "Bucky" Henshaw, US Navy Reserve, had been captured at Wake Island when the Japanese seized it in late December 1941. He had been a public affairs officer and broadcaster. His parents, Mr. and Mrs. Marshall B. Henshaw, greet him at Naval Air Station Honolulu upon his return in September 1945.

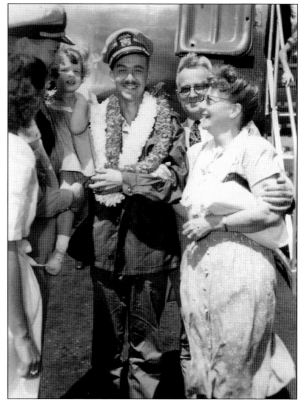

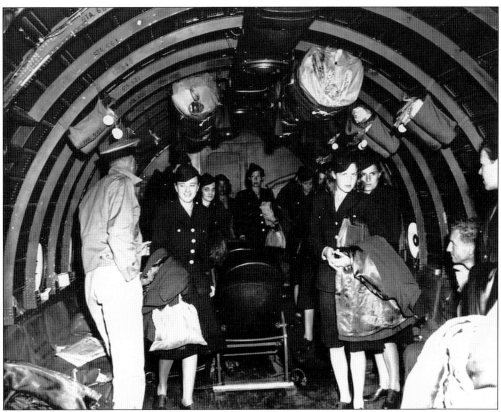

Among the 27,000 American POWs in the Pacific, there were 66 Army nurses and 11 Navy nurses known as the "Angels of Bataan and Corregidor." Taken prisoner in the Philippines, the nurses were held in the Santo Tomas and Los Banos Internment Camps from May 1942 to February 1945. While there, they provided nursing care to all Allied POWS. All 77 women survived. Here, they are arriving in Hawaii after their liberation.

Comdr. Campbell Keene receives a super aloha as he arrives at Naval Air Station Honolulu after being released from a Japanese prison camp. Pictured are, from left to right, Kuulei Moniz, Commander Keene, Nani Panoke, and Ella Correa. The women were members of a hula troupe that joined city officials and senior Navy and Marine Corps officers in welcoming 19 Navy and Marine Corps RAMPs. Most RAMPs stopped in Hawaii returning home.

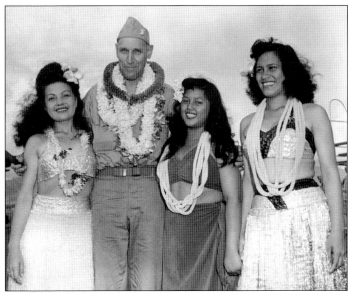

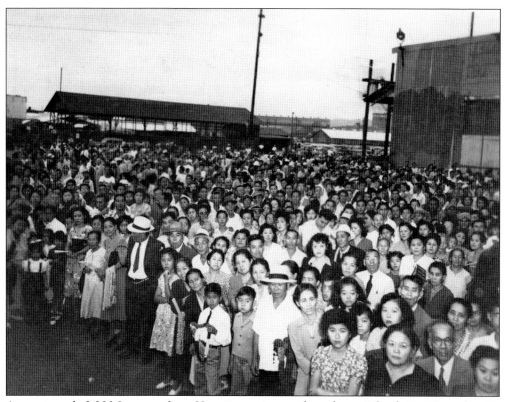

Approximately 2,200 Japanese from Hawaii were interned on the mainland. On November 14, 1945, approximately 450 Japanese returned to Hawaii. Here, crowds lined the dock to welcome a smaller group back on December 11, 1945. (HSA.)

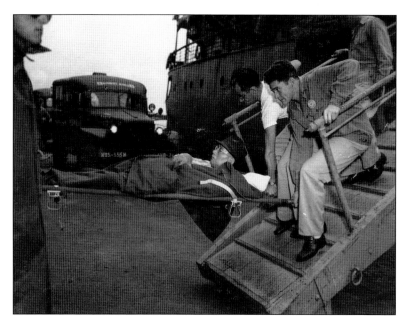

On November 11, 1945, a group of 450 Japanese internees returned to the island. Here, Kan Ooka of Kahului, Maui, returned on a stretcher. Ooka was the owner of Kahului Market.

During the internment period, 504 babies were born in the 10 War Relocation Authority camps. Here, a little girl born in a camp is shown on the Honolulu dock in November 1945.

The last Japanese internment camp closed in March 1946. In 1976, Pres. Gerald Ford officially repealed Executive Order 9066. In 1988, Congress offered a formal apology to the Japanese internees, and Pres. Ronald Reagan signed the Civil Liberties Act, awarding $20,000 each to over 80,000 Japanese Americans as reparation.

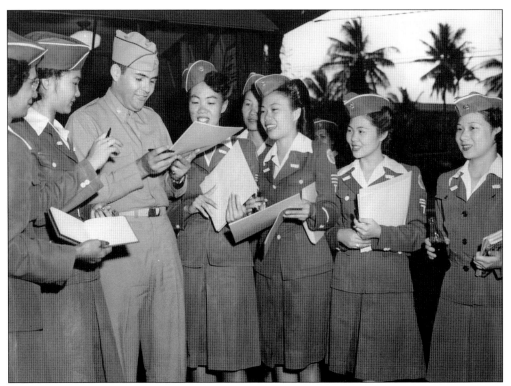

At the end of the last pass in review of the Women's Army Volunteer Corps, Maj. R.W. Groo signs their release from military control. From left to right are Rena Kanealii, Edith Chang, Major Groo, Lani Chong, unidentified, Mildred Luke, Beverly Chang, and Vivian Chong. These women volunteered to drive trucks and buses, and many worked as clerks and administration supervisors at Punahou School with the Army Corps of Engineers.

When the war ended, the civilian volunteer units in all the territory were disbanded. Each island had its own guard, and here, the members of the Molokai Volunteers parade through Kaunakakai, Molokai, for their final review.

Officers and men of the First Hawaii Rifles receive certificates of commendation from Brig. Gen. Herbert Gibson at a ceremony in Hilo marking the release of the territory's Organized Defense Volunteers from military control on July 4, 1945. As they were all volunteers, this was the only form of rewarding their service to the territory.

This photograph was taken on Navy Day in October 1945. It was the first celebrated since the war. Bases were open to the public for static displays, demonstrations, and souvenirs. When the *Missouri* stopped over in Hawaii, teakwood was taken from her quarterdeck by the civilian workers at the Pearl Harbor Naval Shipyard. On Navy Day, cards with slivers of the deck were presented as souvenirs to distinguished guests.

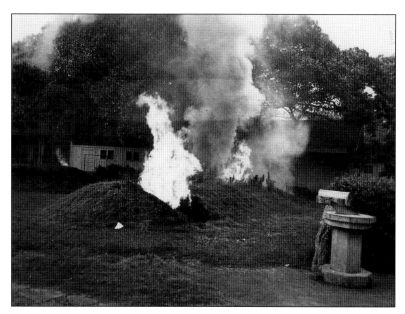

At the beginning of the war, military orders required every household to construct air-raid shelters. By the end of the war, the shelters were rotting with termite-infested lumber and were ordered to be drenched in oil and burned. This photograph shows a bomb shelter at Lincoln School being burned.

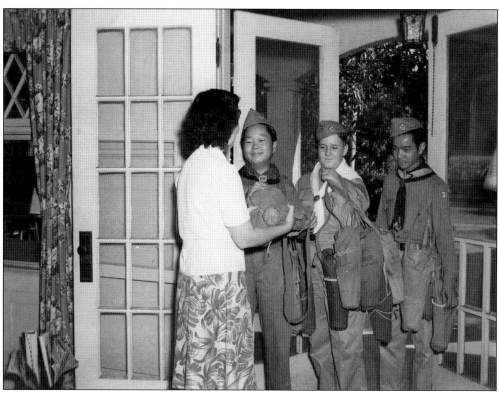

After the war, the government requested that all gas masks be turned in, but many were not. The Boy Scouts went house to house, collecting gas masks that were not turned in. Scouts pictured are, from left to right, Paul Lee of Troop 79, Richard Emerson of Troop 4, and Fredrick Kawamoto of Troop 33. (A few gas masks still turn up in Hawaii antique shops.)

The housing demand saw the federal government launch projects in numerous locations. The Manoa War Homes was the largest, occupying 91 acres, and opened in 1945. Within six months, 1,000 active duty and veteran families occupied the homes. They were demolished in 1959.

The official transfer of government power took place on March 10, known as Restoration Day. The media called it "Emancipation Day," and General Green referred to it as "Confusion Day." But it was not until October 24, 1944, that martial law finally ended. In a symbolic ceremony, Governor Stainback, left, greeted Admiral Nimitz at the Senate session dedicated to ending martial law. On the right is Senate president H.W. Rice of Maui.

121

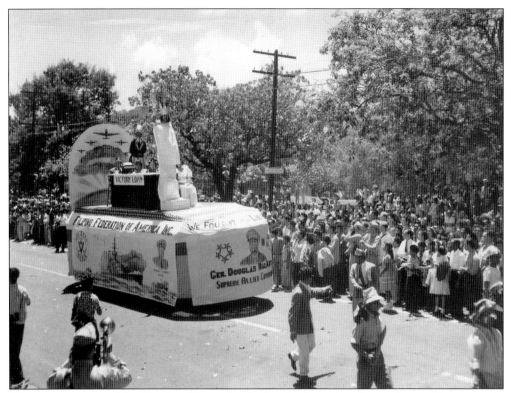

Filipinos were part of the 10,000 soldiers who died in the Japan-led 60-mile Bataan Death March. In 2009, the American Recovery and Reinvestment Act offered a one-time payment of $15,000 for surviving Filipino veterans who were American citizens and $9,000 for noncitizens. Approximately 24,000 claims were denied because applicants needed proof of being on a list of 260,715 Filipino fighters, and the proof was destroyed in the 1973 National Archives fire.

Civilian defense workers proudly carry their state flags in the Honolulu V-J Day parade on September 2, 1945. A majority of war workers were single men between the ages of 20 and 25 who worked 24 hours a day in three eight-hour shifts.

In 1945, the Hawaii Visitors Bureau was established to reinvigorate tourism. In 1947, Aloha Week was launched. An important priority was to get the ocean liner Lurline refurbished from wartime duty. It cost Matson $19 million. In 1948, with a welcome of 150,000 people and an 80-vessel escort, she steamed into Honolulu Harbor, met by the Royal Hawaiian Band, hula troupes, and lei sellers who were back in business.

On September 9, 1945, the USS *Saratoga* transported 3,712 returning naval veterans home to the United States under Operation Magic Carpet. By the end of her Magic Carpet service, *Saratoga* had brought home 29,204 Pacific war veterans, more than any other individual ship.

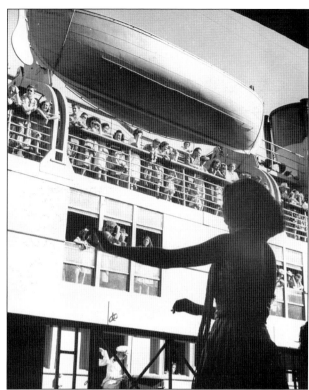

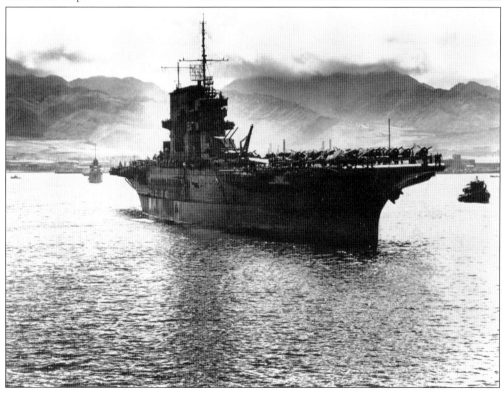

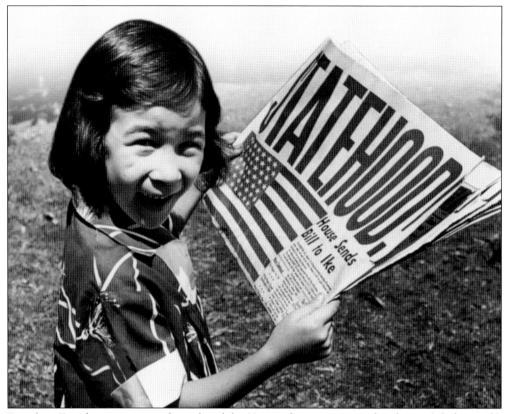

President Eisenhower supported statehood for Hawaii, but appropriate legislation failed to make it through Congress until the Hawaii Admission Act of 1959, when he signed the bill into law on March 18, 1959. In June 1959, the citizens of Hawaii voted on a referendum to accept the statehood bill, and on August 21, 1959, President Eisenhower signed the official proclamation admitting Hawaii as the 50th state.

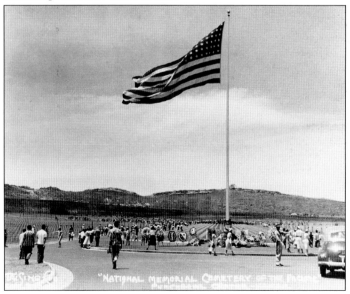

The National Cemetery of the Pacific "Punchbowl" is seen here as it looked at its opening in September 1949. This photograph was taken by Tai Sing Loo, the civilian photographer who worked for the Navy at Pearl Harbor for over 30 years. He captured many iconic photographs during his tenure. (NHHC.)

Nine

Places to Visit

Directional signs on Oahu lead visitors to Pearl Harbor, the USS *Arizona* Memorial, the Punchbowl, and Hickam Field. Being reminded of World War II is a part of life here. On the island, there are a few sites that stand out.

Visitors can reach the Pearl Harbor National Memorial by car or city bus. The *Arizona* Memorial, a short boat ride from the Pearl Harbor Memorial Theatre, looms over the sunken battleship where over 900 sailors and Marines remain entombed. Oil still seeps from the ship, a stark wall of names dominates the memorial, and the ashes of shipmates have been spread in the harbor. Within walking distance of the entrance is the Pacific Fleet Submarine Museum and the USS *Bowfin*, a World War II fleet submarine. With a mix of exhibits, multimedia, and interactive displays, the museum honors "those sailors on eternal patrol."

A complimentary bus ride from the Pearl Harbor National Memorial leads to Ford Island, home of the USS *Missouri* Memorial and the Pearl Harbor Aviation Museum, both highly recommended. The USS *Missouri* Memorial docked next to the *Arizona* provides visual bookends to the war. On the deck of the *Missouri*, there is a plaque marking the place where the Japanese signed surrender documents on September 2, 1945.

The Pearl Harbor Aviation Museum is housed in World War II hangars No. 37 and 79. The museum contains more than 50 authentic aircraft, artifacts, the iconic Naval Air Station Pearl Harbor tower, and a Fighter Ace 360 Flight Combat Simulator. In hangar No. 79, the aviation history continues with the scars of December 7, 1941, still visible.

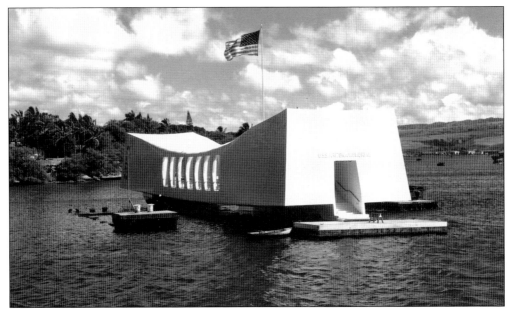

The Pearl Harbor National Memorial is home to the USS *Arizona* Memorial. Visitors are given a video presentation followed by a boat ride to the memorial itself. There is a great museum and gift shop. People are encouraged to visit their online site for information on tickets. This is one of the most popular attractions in Hawaii.

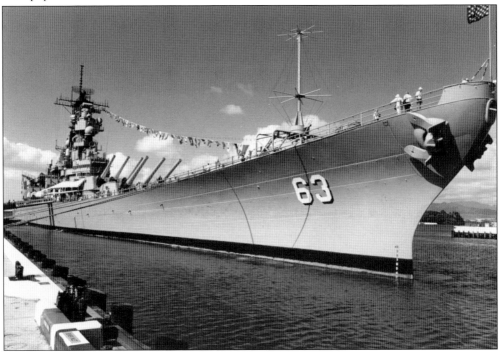

The USS *Missouri* Memorial is the site of the surrender of Japan on September 2, 1945. Since arriving in Pearl Harbor in 1998, it has been restored to the glory of its heyday and offers a unique perspective into Navy life in World War II. Access to the ship on Ford Island is from the national memorial via a complimentary bus.

The same complimentary buses to the active naval base at Ford Island continue on to the Pearl Harbor Aviation Museum. The museum is housed in two World War II hangars and contains over 50 aircraft as well as artifacts from the era. The story of December 7 and the first months of the Pacific campaign are on display with Japanese and US aircraft and stories. The iconic Naval Air Station Pearl Harbor tower, shown here, is restored and open to the public.

The National Memorial Cemetery of the Pacific Punchbowl is a moving and historic site. It can be reached by public transportation or tour company. The Punchbowl was officially opened in 1949, and one of the first to be buried there, after the unknown of Pearl Harbor, was the war correspondent Ernie Pyle. Astronaut Ellison Onizuka and Senators Daniel Inouye and Spark Matsunaga are among the more than 53,000 memorialized here.

DISCOVER THOUSANDS OF LOCAL HISTORY BOOKS FEATURING MILLIONS OF VINTAGE IMAGES

Arcadia Publishing, the leading local history publisher in the United States, is committed to making history accessible and meaningful through publishing books that celebrate and preserve the heritage of America's people and places.

Find more books like this at
www.arcadiapublishing.com

Search for your hometown history, your old stomping grounds, and even your favorite sports team.

Consistent with our mission to preserve history on a local level, this book was printed in South Carolina on American-made paper and manufactured entirely in the United States. Products carrying the accredited Forest Stewardship Council (FSC) label are printed on 100 percent FSC-certified paper.